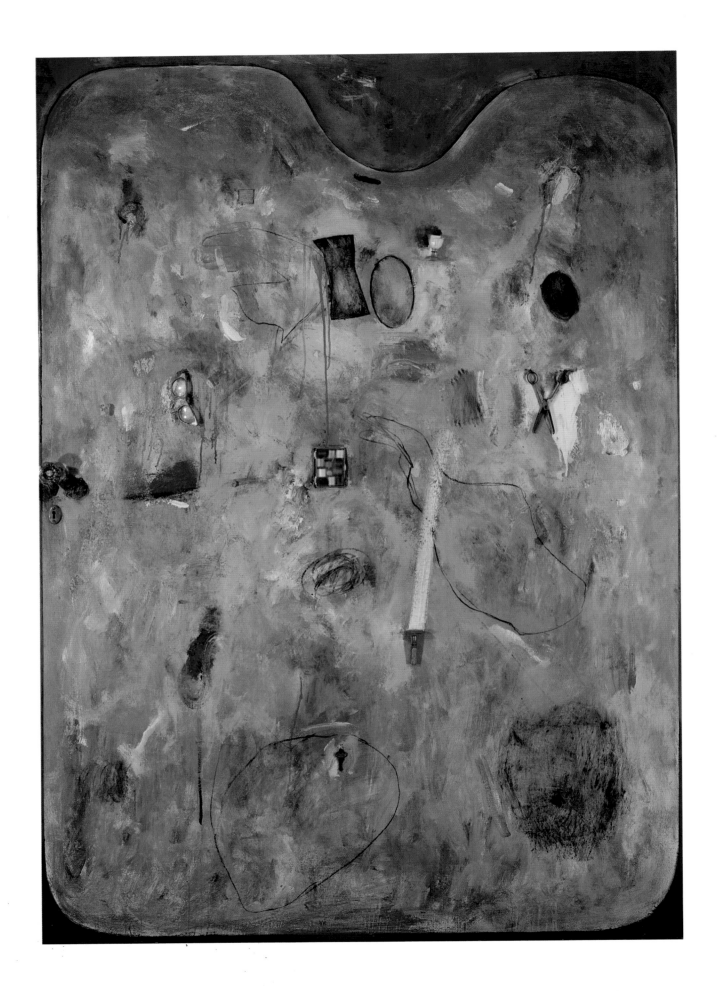

MODERN MASTERS

JIM DINE

JEAN E. FEINBERG

Abbeville Press · Publishers
New York · London

Jim Dine is volume 18 in the Modern Masters series.

ACKNOWLEDGMENTS: It has been my great fortune to have known Jim Dine for many years. We met in 1981 when I was the exhibition curator for the Zilkha Gallery at Wesleyan University, Middletown, Connecticut. At that time Dine was a generous supporter of their print program, and I had the pleasure of poring over his visually luscious printed works for unlimited hours. When I moved to Cincinnati ten years later to join the staff of the Art Museum as their first curator of contemporary art, our dialogue expanded, for Cincinnati is Dine's birthplace and the museum a place of his childhood memories. This book is my thanks to Jim Dine for all that he has done for me over the years—as an artist of inspiration and a friend of unwavering support. From him I learned what the expression "a life in art" really means.

This book could not have been possible without the assistance of the many individuals who surround the artist. I am especially grateful to Nancy Dine and Blake Summers for their help in tracking down images and checking facts. Susan Dunne and Douglas Baxter as well as many other staff members of PaceWildenstein never failed to answer my endless requests, with both accuracy and good humor. Nancy Grubb, my editor at Abbeville, gave this publication its format and polish, showing great patience as this project stretched over several years. Finally, I would like to thank my new friends in Cincinnati, especially those interested in contemporary art, for they welcomed me into Dine's hometown community and helped me make it my own.

FRONT COVER: *A Redheaded Fool*, 1992. Oil, enamel, charcoal, and brush on canvas, 78¼ x 66¼ in. (198.7 x 168.3 cm). Private collection.
BACK COVER: *Fourteen-Color Woodcut Bathrobe*, 1982. See plate 105.
FRONT ENDPAPER, left: Dine, 1988.
FRONT ENDPAPER, right: Dine, 1992.
BACK ENDPAPER, left: Dine working on Crommelynck Gate monoprints.
BACK ENDPAPER, right: One of Dine's temporary London studios, with Venus drawings and paintings, mid-1980s.
FRONTISPIECE: *Objects in a Palette*, 1963. Oil on canvas with mixed media, 84 x 60 in. (213.4 x 152.4 cm). Private collection.

Series design by Howard Morris
Editor: Nancy Grubb
Designer: Steven Schoenfelder
Production Editor: Owen Dugan
Picture Editor: Kim Sullivan
Production Manager: Lou Bilka
Marginal numbers in the text refer to works illustrated in this volume.

Library of Congress Cataloging-in-Publication Data

Feinberg, Jean E.
 Jim Dine / Jean E. Feinberg.
 p. cm. — (Modern masters)
 Includes bibliographical references and index.
 ISBN 1-55859-692-5 (paper). —ISBN 1-55859-751-4 (cloth)
 1. Dine, Jim, 1935- —Criticism and interpretation. I. Dine, Jim, 1935- .
II. Title. III. Series: Modern masters series.
N6537.D5F44 1995
700'.92—dc20 95-15660

First edition
15 14 13 12 11 10 9 8 7 6 5 4 3

Contents

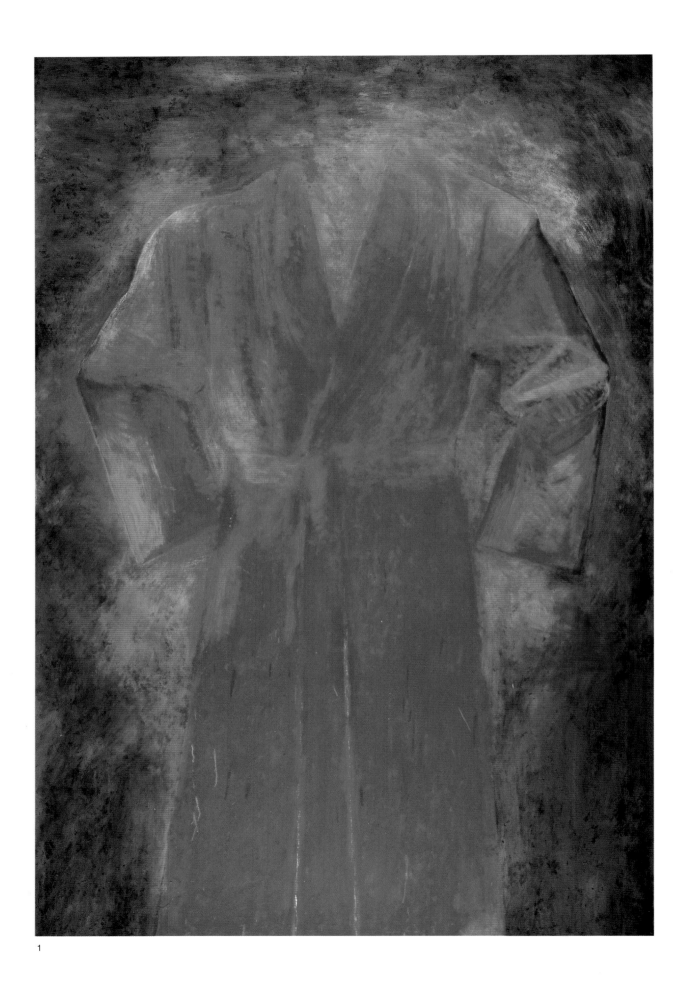

1

Introduction

Jim Dine's transformation from youthful midwestern art student to celebrated New York artist occurred almost overnight. This transpired at the end of the 1950s and the beginning of the 1960s, when he was the youngest among a handful of brash upstarts who stole the art world's spotlight from the Abstract Expressionists. Since that starstruck beginning, Dine has purposefully charted his own independent course. At times his art has helped define the moment; at other stages it has forecast ideas that others would expand upon years later. At times his course has inadvertently led him outside the focus of critical attention, at times he has deliberately distanced himself from the Zeitgeist.

Two profound influences on Dine's art can be discerned. First, his guides have increasingly become not his contemporaries but earlier masters, from ancient to modern. His respect for those who lived the life of art before him has grown as he has grown, and his knowledge of art history is both deep and wide. Second, Dine has, after much initial self-doubt, come to know and trust his inner self. Because Dine's apprenticeship was so short, he had no time to watch the art world from the outside, to learn its ways and then stake out his own territory. He was immediately pulled into the raucous art scene of the early 1960s and elevated to star status, which meant that he had to mature as artist and as an individual under the glaring light of fame. Perhaps for this reason, after his jump-start initiation he came to accept the fact that hand in hand with success went public scrutiny of the "self." He found a source for making art not just in his own private experience of personal growth but also in revealing that experience to the public, and that public exposure became an ongoing motivation, enabling him to forge ahead. In recent years, when asked to explain the twists and turns in his career and his reasons for making one choice over another, the artist has frequently responded, "I have gone where my passions have taken me."

Part of the appeal of Dine's art to the public at large comes from its inherent honesty of emotions. Whether he is motivated by joy or by sorrow, these states of being are right there for the viewer to

1. *Cardinal*, 1976
Oil on canvas, 108 x 72 in. (274.3 x 183 cm)
Private collection

7

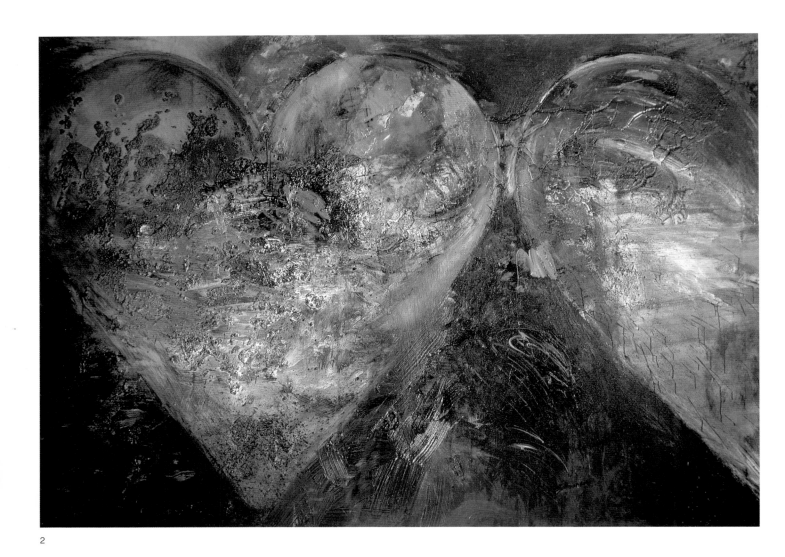

2

grab hold of and experience firsthand. This accessibility of feeling
has a charismatic allure. Such an unabashed display of emotions,
coupled with Dine's respect for his artistic predecessors, is so
unusual at century's end that viewers have even more reason to be
enticed by the rewards that Dine's art offers. Through his art, Dine
turns his passions into ours.

Dine's art is often examined by critics according to one of two
organizing principles. Because he has tackled so many mediums—
performance, painting, sculpture, printmaking, drawing, and book
illustration—his production in each medium can be isolated and
analyzed separately to great benefit. Yet this approach has often
left curators, critics, and the public with the inaccurate perception
that Dine is principally a printmaker, or a painter, or a draftsman.
Also, because Dine has worked with certain recurring images, his
oeuvre has frequently been examined and exhibited in terms of
these subjects: his tools, his hearts, his gates, his Venuses. Again,
the drawback of this approach is that it presents Dine's production
as narrower than it actually is.

This volume sets aside these two approaches in favor of a
chronological examination of his life and art. It aspires to capture
the essence of his constant experimentation, tremendous ambition,

2. *Painting a Fortress for the Heart,* 1981
Acrylic on canvas, 84 x 120 in. (213.4 x
304.8 cm)
Private collection

3. *Harvard Self-Portrait Without Glasses,* 1978
Etching, 25¾ x 20 in. (65.4 x 50.8 cm)
Edition of 10, published by Pace Editions

4. *The Artist as Narrator,* from *The Apoca-
lypse: The Revelation of Saint John the Divine,*
1982
Woodcut, 11¾ x 9 in. (30 x 23 cm)

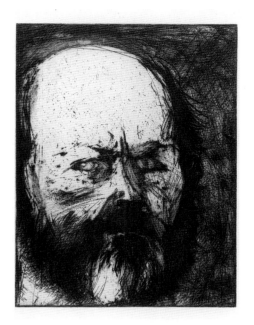

3

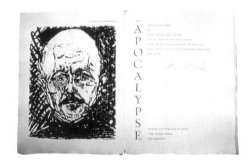

4

and prolific output. One characteristic factor has unified all of Dine's art: his veneration of the familiar—that is, his devotion to often ordinary objects and his elevation of them to multifaceted symbols. Dine's process has always been to discover something— usually a found object or image—that somehow resonates for him and then to invent a new meaning for it. He does not select neutral images from popular culture. Rather, he picks everyday objects that have personal or cultural meaning for him. This process began in his earliest days, when he gathered junk from the streets around the Judson Church in Greenwich Village in order to create an environment for a Happening brimming with life. It continues now with his adaptations of a kitschy plastic souvenir statue of the Venus de Milo and a nineteenth-century porcelain figurine of an ape and cat.

Dine's art is characterized by the investment of multiple layers of meaning in the objects he depicts. He projects part of his psyche, his emotional inner being, onto these objects, so that each one becomes a container that he fills and then uses as an instrument of communication with the viewer. Dine takes a paintbrush—whether it is a depiction of a paintbrush or the real tool itself—and isolates it from its functional context, letting it hang in midair. Or he empties a man's robe, so that it floats bodiless in atmospheric color. He turns these images into repositories of his own emotional state, but at the same time viewers are seduced into projecting their own feelings onto the subject.

Occasionally there is humor in Dine's work, but more often it communicates pathos, sexual rapture, or joyous beauty. Never is there irony, cynicism, or a distant intellectual stance. Because the artist is never cool or disengaged, the viewer is never left feeling out in the cold. We are all forced, when viewing a work of art by Jim Dine, into a position of psychic projection and emotional involvement. Universally recognized forms, such as a heart, are transformed from being commonplace or even trite to being highly personal. The mundane is reinvented and thus reinvested with meaning. Although Dine has painted, drawn, and sculpted hundreds of hearts, robes, tools, skulls, and Venuses, no two have ever been alike. For example, the most basic contour of the heart—its bulging, breastlike curves—has remained constant, but its symbolic value has been newly investigated again and again. Each shape is merely a template, a starting point for the artist's never-ending invention.

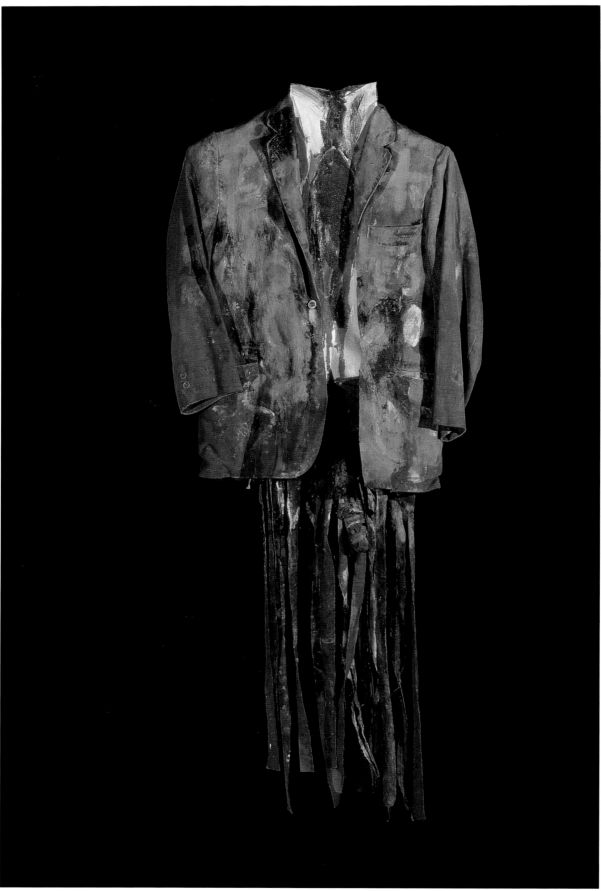

1 From Ohio to New York

Jim Dine was born and raised in the midwestern town of Cincinnati, Ohio. At mid-century this quiet river city offered his middle-class Jewish parents a comfortable environment in which to live, work, and raise their first son, "Jimmy," and his younger brother, Tom. Dine's early memories are pleasant ones, dominated by the love of his mother, his childhood jobs in his father's commercial paint and plumbing-supply store and in his grandfather's hardware store, and his first exposures to art.[1]

Dine recalls enjoying his frequent visits to the Cincinnati Art Museum, which he still credits with having introduced him to classical sculpture and several centuries' worth of European and American painting. He reminisces about walking through the museum's galleries filled with pictures by local artists, such as Frank Duveneck and John Henry Twachtman, and thinking that if they were born in Cincinnati and still had managed to travel the world and one day return to see their paintings hanging in these hallowed halls, then a similar future might be possible for him. As a young boy Dine took art classes at the museum, and in the early 1950s he attended Paul Chidlaw's more advanced evening adult classes at the adjacent Art Academy. In between, he attended classes at a studio school run by the local artist Vincent Taylor; many years later Dine still remembers the sable brushes that Taylor required his students to use.

Dine's reminiscences about his early life turn from the carefree pleasures of this conservative, closely knit, and prosperous postwar community to the troubled memories that began in 1947, when his mother became ill and died of cancer. Her death, followed by his father's remarriage, brought about family upheaval. Rather than live under the same roof as his stepmother, Dine spent the next several years with his maternal grandparents and with an aunt and uncle.

Dine graduated in 1953 from Walnut Hills High School, the city's prized college-preparatory academy, which gave him an excellent classical education. Then the aspiring artist embarked on the peripatetic wanderings that have marked his life ever since. He

5. *Green Suit*, 1959
Oil on cloth, 62 x 24 in. (157.5 x 61 cm)
Private collection, New York

began his undergraduate studies at the University of Cincinnati but quickly transferred to Ohio University in Athens, Ohio. Before graduating with a B.F.A. in June 1957 he spent the fall 1955 semester at the Boston Museum School. He stayed on in Athens for a year of graduate study in studio art, making numerous weekend visits with friends to New York City. In the fall of 1958 he and his wife, Nancy Minto (a fellow Ohio University student), moved to New York. First they lived in Patchogue, Long Island, where they both taught in the public school system. A year later they moved into Manhattan, where Dine supported the family[2] by teaching for two years at the private Rhodes School. By 1962 their lives had radically changed. Dine was able to support them through his art, having progressed from what he has described as an unsophisticated midwestern youth to a star of the New York art scene.

Even though the tales of the Abstract Expressionists emphasize how they gathered downtown (that is, below Fourteenth Street) for late-night conversation and drinking, by 1958 they had come to be considered part of the "uptown" establishment. Since the close of World War II the Abstract Expressionists had gradually taken command of the national and eventually the international art world. Young artists not interested in becoming second-generation Abstract Expressionists had to stake out their own territory. Immediately upon his arrival in New York, Dine became one of the handful of artists who would create a newly dynamic "downtown" scene.

Shortly after arriving in New York, Dine met Allan Kaprow, an artist who was then an influential teacher at Rutgers University. Although Dine never officially studied with Kaprow, he acknowledges that their relationship was one of teacher and student. A forceful individual who preached the necessity of continual change, Kaprow believed that all artists had to push forward, and at this time that meant moving beyond what had been achieved by Jackson Pollock. Easel painting was dead; art was to be the event of its own making. The Duchampian blurring of the distinctions between art and nonart objects was to be embraced, so that everything became a potential component of art. Everyday junk could be transformed into the materials of artmaking. Kaprow was a cheerleader for many young artists eager for this kind of encouragement. As Dine would say many years later: "Kaprow . . . made us feel important in a revolutionary way. He made us feel like brave young soldiers being put in the trenches, the first ones to go over the hill. We felt like that all the time because of what was being said around us. Our egos were fed. The performances became a kind of 'painter's theater.'"[3]

In 1960 Dine created an environment entitled *The House*, which was his contribution to a two-person exhibition (with his friend Claes Oldenburg) at the Judson Gallery. From early descriptions and documentary photographs we know that Dine went out into the streets of Manhattan during a snowstorm, filled what appears to be a baby carriage with urban street debris, and wheeled it into the Judson Gallery.[4] Once inside, he combined these finds with, among other things, hand-lettered signs, painted cutouts of faces, ripped clothing, and rags, transforming the gallery into a high-

6. *Untitled (Head)*, 1959
Oil on canvas, 27 x 20⅛ in. (68.6 x 51 cm)
Nancy Dine

7

8

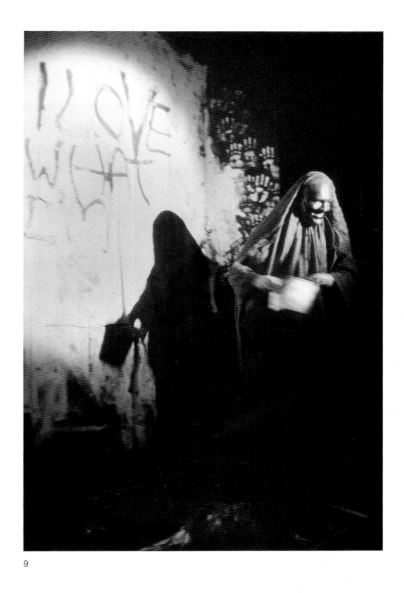

9

energy junkyard of clutter and confusion. What we now rely on, in addition to the rare documentary photographs, to help us understand the radical nature of *The House* are a few related works: an untitled face painting, *Green Suit, Shoes Walking on My Brain,* and *Bedspring.*[5]

6, 5, 14

8

By titling his first environmental installation *The House*, Dine made clear that he was serious about transforming the gallery into a space of another sort. It is not another "artspace" but his home, a domestic environment. It also became the stage for his first performance—the thirty-second-long *Smiling Workman*. In that event Dine appeared less like a "workman" than a bizarre actor, with a red-painted face and sheathed in a long robe. He stood before a low table covered with paint buckets. Behind him was a wall (actually a sheet of paper) on which he printed in orange and blue block letters: I Love What I'm Doing. Then he drank from the buckets of red paint, poured the remaining contents over his head, and jumped through the paper wall. In other words, he consumed paint, drenched himself in it, and then broke through the mock picture plane, having declared that he loved what he was doing, in

7, 9

15

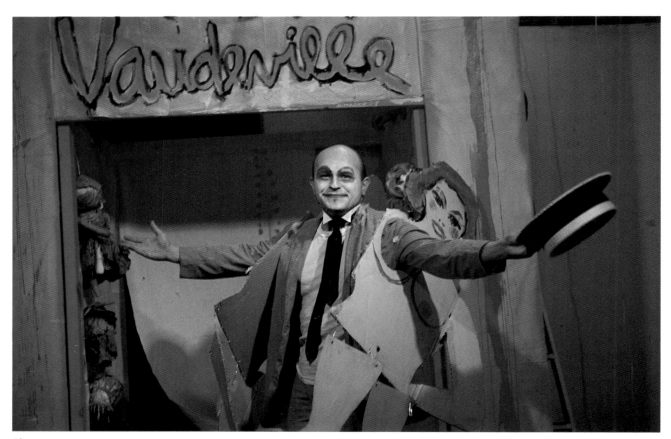

10

clear opposition to the angst-driven despair that supposedly characterized the Abstract Expressionist's private studio experience.

The same surreal incongruity, raucous sense of humor, and abandonment of convention characterized Dine's second Happening, *The Vaudeville Show.* This event, which took place at the Reuben Gallery, climaxed with Dine dancing on stage with two life-size cardboard female companions, in a soft-shoe routine that was truly vaudevillian. Present at this performance was critic-curator Alan Solomon, who wrote a few years later that it was impossible to communicate the "electrifying" quality that Dine's "charismatic" performance had on its small downtown audience.[6]

Just a few months later Dine staged the *Car Crash.* Related paintings, drawings, and lithographs—some of which hung in the entryway of the Reuben Gallery, where the performance took place—provide visual evidence of the performance's macabre intensity. *Car Crash* was not only Dine's cathartic reenactment of his personal experience of a real accident but also a potent metaphor for danger, tragedy, and the omnipresent specter of death that Dine sensed in American life. Three actors—Pat Oldenburg, Marc Ratliff, and Judy Tersch—helped him enact the events. Dine, with his head bandaged, wore a silver jumpsuit; he described the crash by drawing the car again and again in a manic action that was reinforced by a sign that repeated the word HELP over and over. As in his other performances the scene was crude, disorderly, and intense. A cemetery cross loomed overhead, and many of the accu-

10. Dine in *The Vaudeville Show*, 1960

11. Dine in *Car Crash*, 1960

16

mulated props, which were intended to suggest both the accident and hospital sites, were painted white. A few years later John Russell described *Car Crash* as "the 1960s Massacre of the Innocents: the sordid, bloody, destructive incident that fate may put in anyone's way. . . . It is Black Death, plague and pox rolled into one."[7]

Dine's engagement with Happenings did not result in his turning against studio-created art, as Kaprow had preached. In fact, the stress of staging these highly personal expositions sent him back to the studio in order to make works that certainly could not be called traditional art objects but that were discrete objects and could be shown in a traditional gallery context. This switch by no means meant that Dine was rejecting the aesthetic of the Happening, nor was he withdrawing from the art scene; rather, he was being pulled even more into the limelight. Between 1960 and 1966 Dine had a solo show at the Reuben Gallery, a solo show at the Martha Jackson Gallery, and three solo shows at the Sidney Janis Gallery—all in New York City. He participated in Jackson's seminal group exhibitions, *New Media—New Forms I and II*[8] and *Environments, Situations, Spaces,* as well as the significant *New Realists* exhibition at the Sidney Janis Gallery in 1962. According to Harold Rosenberg, the Janis show, which opened on Halloween, "hit the New York art world with the force of an earthquake."[9] Many of the Abstract Expressionists regularly exhibited at Janis: Willem de Kooning, Robert Motherwell, Mark Rothko, Adolph Gottlieb, and Philip Guston. As a result, for Janis to show work by

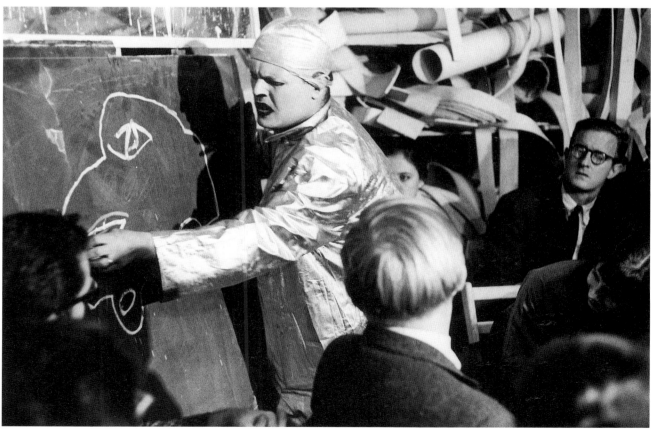

11

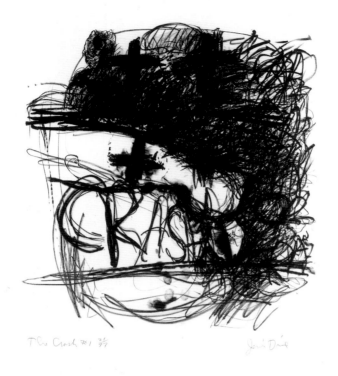

The Crash #1 ...

12

twenty-nine realists such as Roy Lichtenstein, Claes Oldenburg, James Rosenquist, Wayne Thiebaud, Andy Warhol, and Tom Wesselmann was viewed as sacrilege. Sides were taken, swords were drawn, and within a few days all the Abstract Expressionists (with the exception of de Kooning) had decided to leave the gallery.

David Bourdon called *The New Realists* show "the apotheosis of the emerging Pop tendency [and] . . . the most provocative art event of the season, marking one of the most divisive moments in the history of the New York art world."[10] Divisive or no, Pop was almost immediately embraced, despite intense outrage from some critics and from many of the Abstract Expressionists. As Bourdon noted: "While Pop art's significance was still being debated within the art world, its impact was already rippling through society, influencing the look of architecture, home furnishings, housewares, fashion, advertising and graphic design. . . . By spring of 1963 every with-it museum in the nation seemed to be mounting a Pop art exhibition."[11]

The controversy over Pop art created a problem that would plague Dine and many critics for several decades. Even though the look, intent, and attitudes of Pop art were radically opposed to the style, intent, and belief systems that characterized Abstract Expressionism, many artists of the younger generation—particularly Dine, Jasper Johns, Oldenburg, and Robert Rauschenberg, as opposed to Rosenquist, Warhol, and Wesselmann—did not at that

12. *The Crash No. 1*, 1960
Lithograph, 29 ⅞ x 22 in. (76 x 56 cm)
Edition of 33

time consider themselves to be aggressively rejecting Abstract Expressionism. At this point in his life, still just in his late twenties, Dine knew that he had to create his own vision, to develop his own vocabulary, and (as Kaprow had taught him) to be avant-garde. But Dine also had tremendous respect for the older artists around him, and he never considered his use of the object in his art as a violation of or a defection from Abstract Expressionism. Nevertheless, that is how many critics labeled it. In a 1963 interview entitled "What Is Pop Art?" Dine stated his position with great respect and only a trace of rebelliousness: "I don't believe there was a sharp break and this [Pop art] is replacing Abstract-Expressionism. Pop art is only one facet of my work. More than popular images I'm interested in personal images. . . . I tie myself to Abstract-Expressionism like fathers and sons."[12] In fact, Dine maintained, exploited, and in later years revitalized the abstract gesture. And like the Abstract Expressionists, he put great stock in his interior life as source material, both the joys and anxieties of daily life and less easily accessible imagery from dreams and the unconscious.

In their haste to label the new Pop art movement, many critics defined it too narrowly. Their restrictive identification of Pop as cool, antiexpressive, ironic, and so forth put Dine on the defensive and later caused him to repudiate his Pop associations. Dine was, of course, a prominent member of American Pop, yet his work was always very "hot," very expressive; though often witty, it was serious without being cynical.

The two subjects that dominated Dine's solo exhibitions of 1962 and 1963—clothing and bathrooms—were ones that he shared with other artists of the time, including Oldenburg and Wesselmann. Over thirty years later, it is hard to conjure up how radical was the sense of ordinariness that these commonplace images projected. Dine focused on articles of clothing, such as shoes and ties. In his earlier *Green Suit* a shirt and tie hang from an empty collar. 5 There is no torso in the suit, but as our eyes move downward we become aware of an exposed penis that hangs among the torn trousers, which have been shredded like raffia. The sexual organ is the only physical aspect of the man that is present. The way the gray tie hangs from the neck just above the penis makes its parallel signification of maleness obvious, and so when Dine isolated and enlarged a single silver tie, the sexual symbolism could not go unnoticed.

In *Shoes Walking on My Brain* a pair of men's loafers is making awkward but threatening steps toward a frightened man's head. 14 Large eyes loom out from what might be viewed as bedcovers, giving a nightmarish overtone to this harrowing assemblage. In other works, such as a drawing of three swaying ties and *Shoe*, the highly 113, 15 evocative tone of *Green Suit* and *Shoes Walking on My Brain* has been cooled down without eliminating the images' suggestiveness. Painted in profile, *Shoe* is a rather dapper brown-and-white man's shoe, isolated against a monochromatic field. In case its identity wasn't clear enough, Dine painted, in the same blunt lettering he used in his Happenings, the word SHOE under the painted shadow of the shoe. Of course this calls into question the nature of depicted versus actual reality. The wooden ledge attached to the bottom of

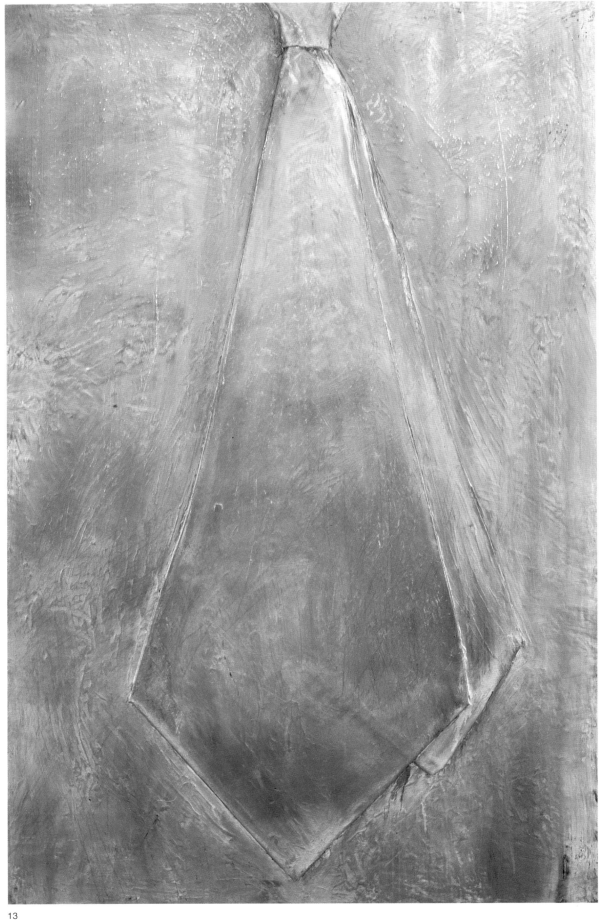

13

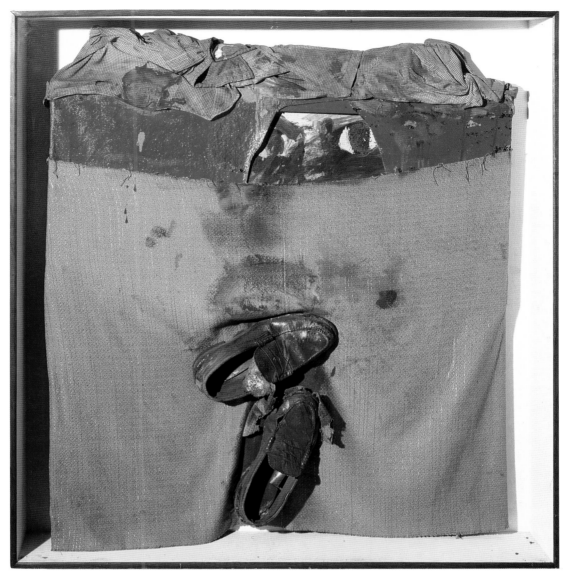

14

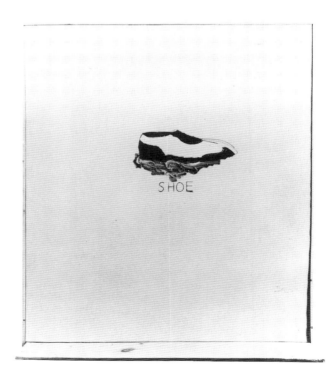

13. *Nancy's Tie,* 1960
Oil on canvas, 63 x 39½ in. (160 x 100.3 cm)
Nancy Dine

14. *Shoes Walking on My Brain,* 1960
Oil, canvas, and leather, 40 x 36 x 6 in.
(101.6 x 91.4 x 15 cm)
Private collection, New York

15. *Shoe,* 1961
Oil and collage on canvas, 64 x 51½ in.
(162.6 x 130.8 cm)
Private collection, New York

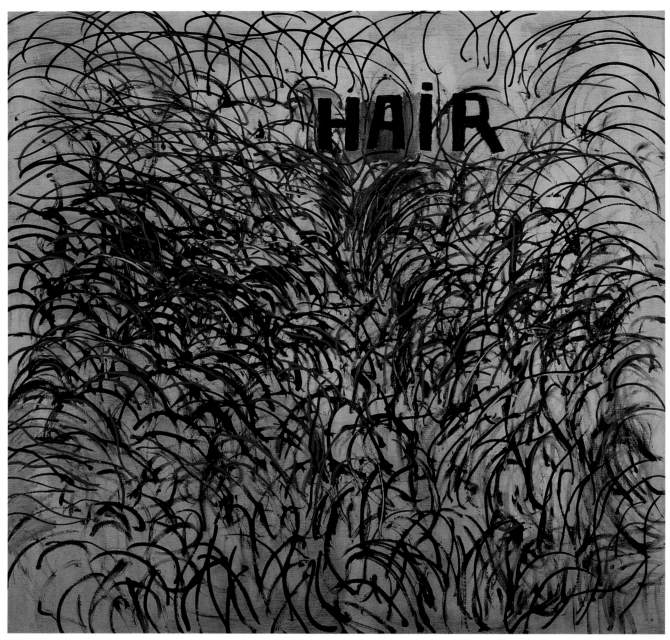

16

the canvas gives the work a resemblance to a blackboard and thus suggests that the artist is teaching a lesson about the illusionistic nature of art.

In all the photographs of Dine from this time onward one can't help noticing that the artist started balding at a very early age. In 1961 he made the first of what were to be many works that use hair as a subject for linear gesture as well as a potent symbol of sexuality. Just as *Shoe* was bluntly identified by the word SHOE, so Dine identified the subject of his hair painting: the title stands out boldly amidst the strokes of paint on a monochromatic field of skin tones.

Given that Dine's environmental piece *The House* took as its subject the domestic setting, it is not surprising that when he went

16

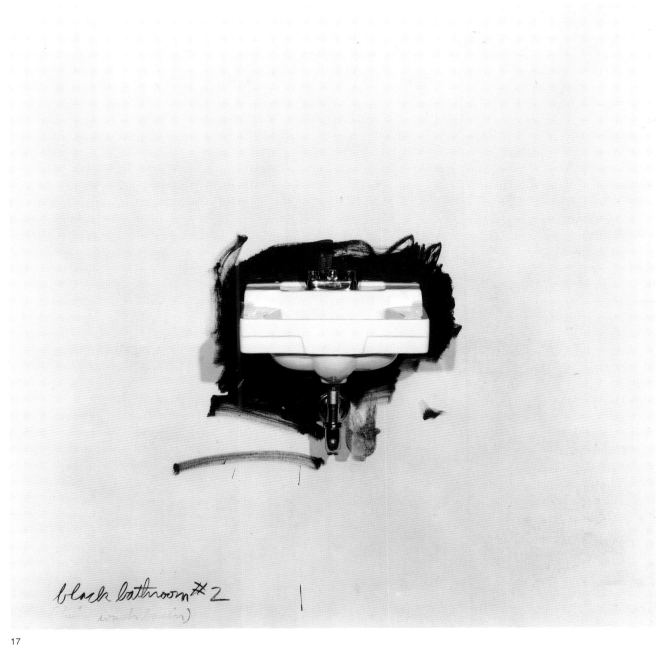

black bathroom #2
(washbasin)

17

16. *Hair*, 1961
Oil on canvas, 72 x 72 in. (183 x 183 cm)
Reinhard Onnasch, Berlin

17. *Black Bathroom No. 2*, 1962
Oil and drawing on canvas, with porcelain sink,
72 x 72 in. (183 x 183 cm)
Art Gallery of Ontario, Toronto; Gift of Mr. and
Mrs. M. H. Rapp, 1966

back into the studio he again created works suggesting the space of actual rooms and the objects that fill them. In these works he blended the use of real objects that characterized his early works with the mastery of illusion that came out of his studio experience.

What room in a home is more personal yet more mundane than the bathroom, with its sink, shower, water glass, and toothbrushes? In *Small Shower* (private collection) Dine affixed a showerhead just below the top of the canvas, where he also adhered white enamel letters that spell out what we see: SHOWER. Painted water flows from the real showerhead in a cascade of staccato black-and-white strokes. The implied shower-stall wall is a zigzag of bold horizontal gestures. *Black Bathroom No. 2* puts this interplay of the real and the implied to even more dramatic and starker effect. Here a

17

porcelain sink is suspended from the center of the canvas, surrounded by black paint that is as boldly applied as a Franz Kline stroke.

19 *Lawnmower* plays on the same principles. It is a single work with three parts: the lawnmower, a pedestal that elevates the lawnmower to sculptural status, and a painted panel upon which the handlebars of the mower lean. Thick dabs of green and yellow paint on the mower suggest that it has recently been used, perhaps to cut the grass in the suggested landscape. Painted blades of grass with a hint of summer sun meld the mower and the painting so thoroughly that this assemblage becomes a visual metaphor for a summer day and the all-American weekend activity of tending one's lawn. When these works were shown in 1963, they were considered shocking, thereby reinforcing the reputation as a daring provocateur that Dine had established with his Happenings.

Dine made *Lawnmower* in East Hampton during the summer of 1962. The commercial success of his show of ties and other objects the winter before had made it possible for him to quit his teaching job and to rent a summer house on Long Island. During that summer he spent hours in the local hardware stores, and for the first time he had enough money to buy whatever supplies he wanted. Thus began the embodiment in his art of his lifelong romance with tools, a love affair that had begun when he was a young boy amusing himself in his grandfather's hardware store and his father's plumbing supply and paint business. Dine has often mentioned that he worked in his father's and grandfather's stores from the age of nine until he turned eighteen and how visually pleasing the display of the tools was for him. Over time they became "objects of affection . . . [that] felt like relatives of mine, as though their last name was Dine."[13] Again the artist transformed his raw material with his characteristic interest in both the real and the depicted.

19
20 This is seen in the real axe atop the real window in *Window with an Axe* versus the printed pliers and scissors in the print *Cut and Snip*. In the former he transformed the actual functional objects into sculpture; in the latter he relied on their drawn illusion.

Dine's first tool print was created at Universal Limited Art Editions (ULAE), where his friend Jasper Johns took him during the summer of 1962. There he met Tatyana Grosman, long before she had become known as the grand dame of the American renaissance in printmaking. During the 1960s Dine was to create twenty-three editions at ULAE, and he later stated that "Working with Tanya Grosman . . . has been the catalyst for everything [in my printmaking]. She is the only person I have ever met with standards for everything from coffee to violet litho ink. She has made me aware of paper."[14]

Cut and Snip is fundamentally a simple lithograph; however, the line drawing of the tools combines with the bold gestural splash of tusche on handmade Auvergne paper to yield a print of wit and energy. Again (as in *Black Bathroom No. 2*) realistic depictions of common objects are merged with the messy gestures of the abstractionists. The tools dance across the sheet with abandon, their cutting and snipping activities becoming lively movements. There is no deadpan illustration here.

18. *Lawnmower*, 1962
Oil on canvas and lawnmower on painted wood base, 77½ x 36 x 19 in. (197 x 91.4 x 48.3 cm)
Private collection

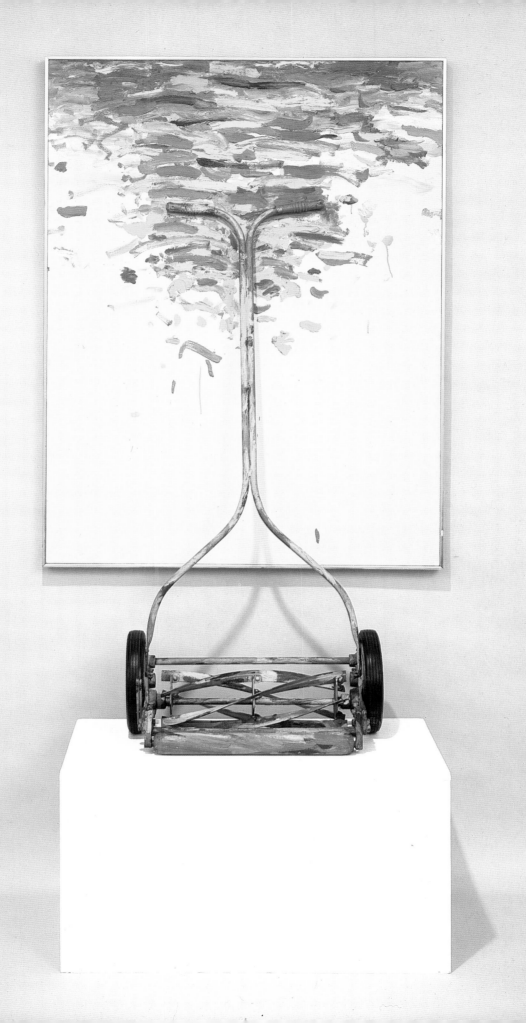

19

20

At the same time that Dine embarked on his lifelong study of tools, he also created works that incorporated familiar elements from the painter's own bag of tools. In *The Studio: Red Devil Color Chart No. 1* he reproduced twenty-four blocks of color taken directly from the sample charts of commercial paint supplied by the Red Devil manufacturer. Dine labeled each sample block with its color name. Since this chart has been blown up to a size that belies its original function, the painting could be misread as an early Minimalist composition. But ignoring the source of the composition deprives it of its meaning: the innate beauty of the chart itself as a housepainter's sourcebook. Dine elevated the utensils of the artist's trade because he considered them beautiful and meaningful in their own right. (And don't forget that the workman of Dine's *Smiling Workman* was, in fact, a housepainter.) The same motivation holds true for Dine's palette pictures. In the one from 1969,[15] Dine has foregone the manufacturer's neat display of choices evident in *Studio: Red Devil Color Chart No. 1* for the messy ooze and drips of a working artist's palette. It communicates a richness of sensation that relates to the artist's most expressive tendencies.

In 1964 Dine introduced the subject that is one of the most popular and appealing images of his career: a man's bathrobe. His first group of robe paintings was created specifically for a group exhibition held early that year at Janis Gallery. In true Pop spirit, Dine took the image from an advertisement in the *New York Times,* in which the model had been airbrushed out of the photograph. The connection between Dine's robes and his *Green Suit* from five years before cannot go unnoticed. As if endorsing the platitude "clothes make the man," Dine transformed both the suit and the bathrobe into representations of himself. Not yet willing to draw or paint a realistic likeness—an activity that would have seemed unthinkably retrograde in the American art world of the mid-1960s—Dine nevertheless could not shake off his desire for portraiture. He dealt

101

19. *Window with an Axe,* c. 1961
Wood, painted glass, and axe, 63½ x 32 in. (161.3 x 81.3 cm)
Private collection, New York

20. *Cut and Snip*, 1962–63
Lithograph, two sheets: 24¾ x 19⅝ in. (63 x 50 cm), each
Edition of 21

Page 28
21. *The Studio: Red Devil Color Chart No. 1,* 1963
Oil on canvas, 84 x 60 in. (213.4 x 152.4 cm)
Alice F. and Harris K. Weston

Page 29
22. *Red Robe with Hatchet (Self-Portrait),* 1964
Oil, metal, canvas, and wood, 87 x 60 x 24 in. (221 x 152.4 x 61 cm)
Virginia Museum of Fine Arts, Richmond; Gift of Sydney and Frances Lewis

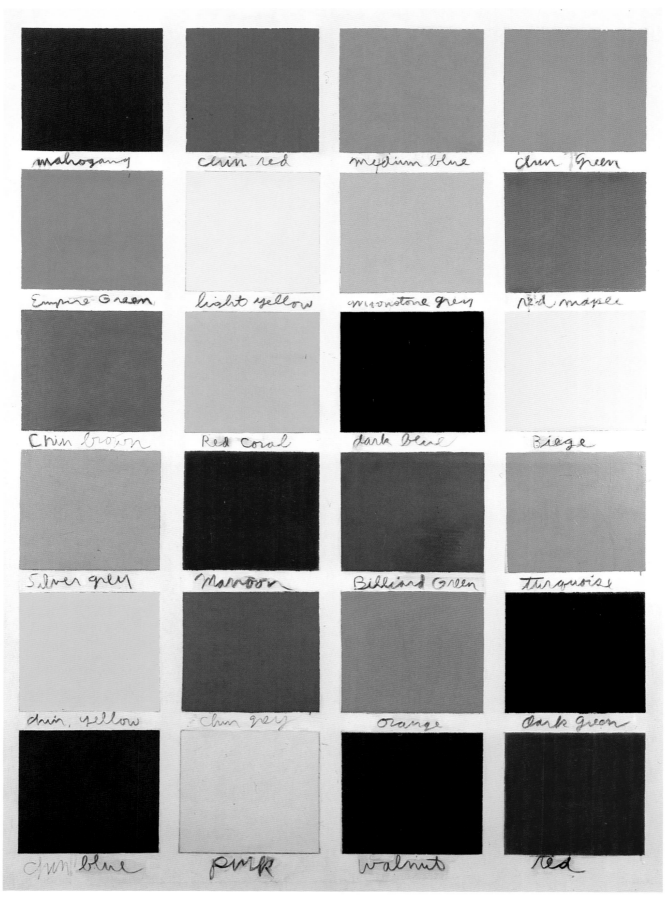

mahogany	chin red	medium blue	chin Green
Empire Green	light yellow	moonstone grey	red maple
Chin brown	Red Coral	dark Blue	Biege
Silver grey	Maroon	Billiard Green	Turquoise
chin, yellow	Chin grey	orange	dark green
chin blue	pink	walnut	red

21

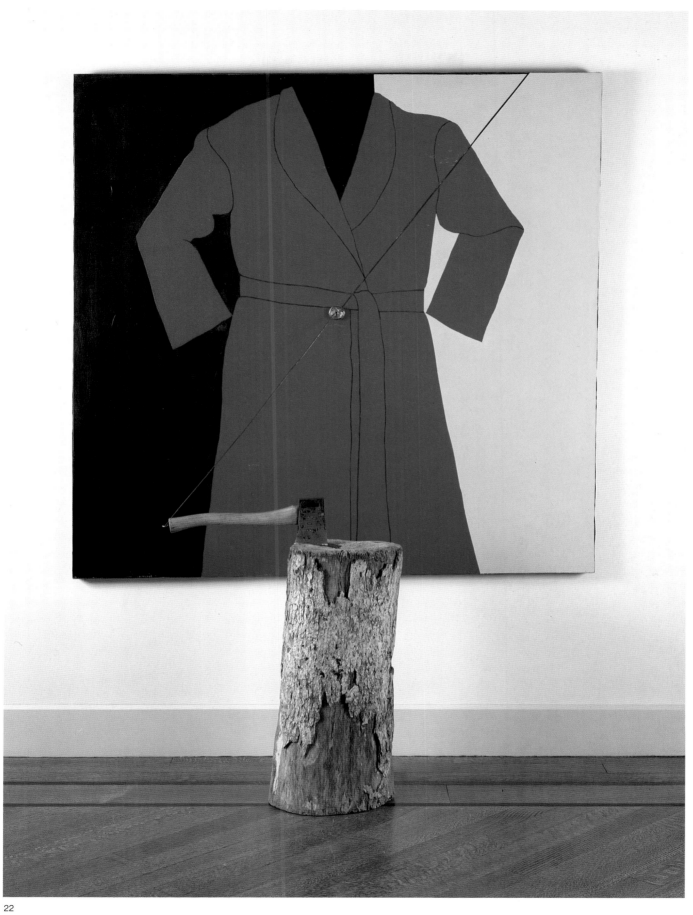

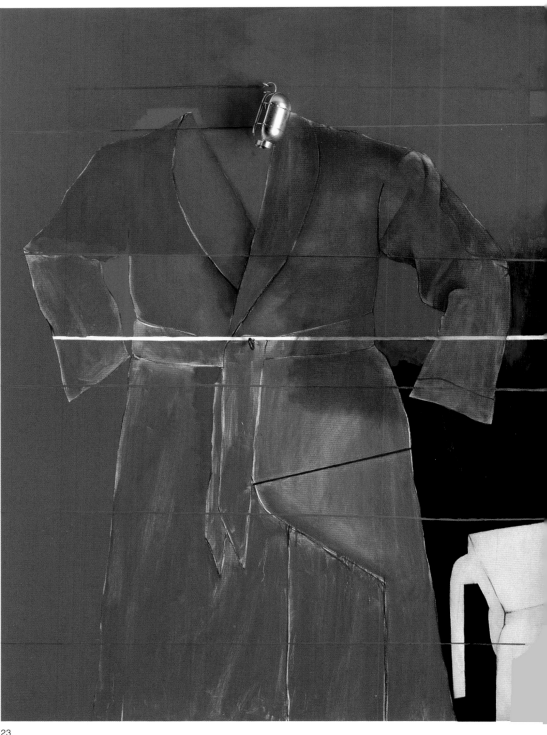

23

with this conflict by succumbing only partially to the pressure of those times; he refused to ignore his desire for self-depiction, but he also felt compelled to find a way to explore this historically revered endeavor without jeopardizing his position in the contemporary art community.

Dine made it clear that the robes were intended as self-portraits through some of his first titles: *Red Robe with Hatchet (Self-Portrait)* and *Double Red Self-Portrait (The Green Lines)*. He later

23. *Double Red Self-Portrait (The Green Lines)*, 1964
Oil on canvas, two panels: 84 x 60 in. (213.4 x 152.4 cm), each
Private collection, Montreal

30

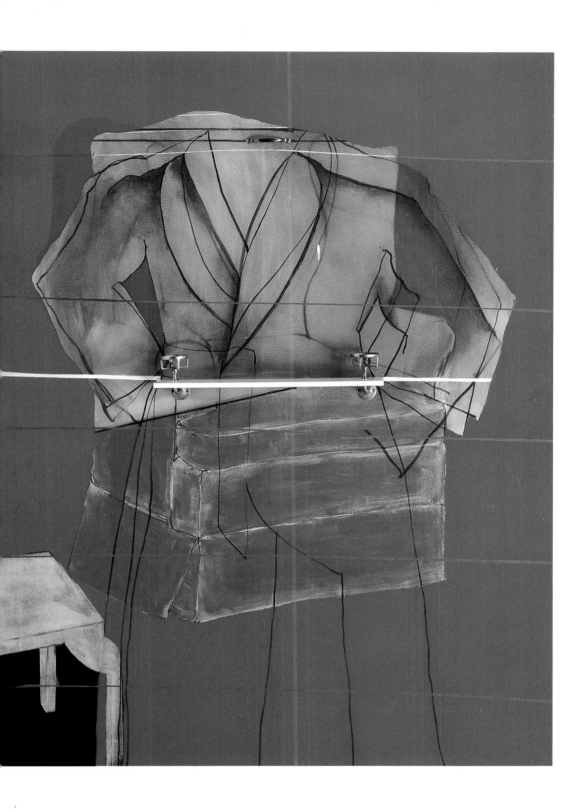

admitted that the red version and others of this time are "rigid"; he was still loath at that point to improvise or interpret. The only visual aspect of these early robes that identifies them as Jim Dine is the broad, stocky outline, which mimics his body shape of the period. Also in 1964 Dine explored the self-portrait in drawing and printmaking. In *Running Self-Portrait (L.L.Bean)*[16] he utilized a related figure (again based on a photograph from the *Times*), of the tennis player Bill Tilden, and for his first published etching, *Bathrobe*,

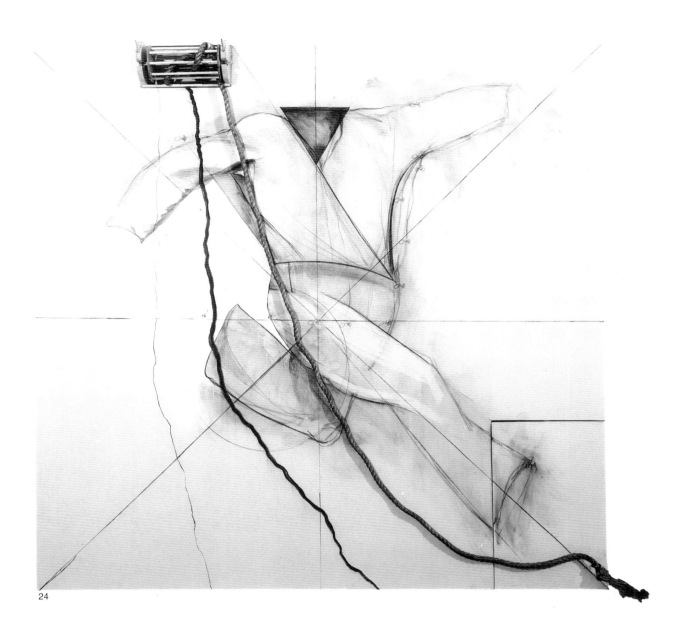

24

he made a robe composed of loops upon loops of black line.

The emptiness of these early bathrobes—which is what one notices first—has always been particularly striking. The dumb flatness, the cool Pop reserve, emphasizes the emptiness. The robe stands alone; it is not hung on a hanger. With arms akimbo, it has the shape that a torso would provide, but there is no one there. The tension of something held back, not told, not depicted, is reinforced in the print version by the tight, energetic scribble of the etched line, which is frantic in its intensity. Nonetheless, this expressiveness is tightly contained, held in by the solidity and strength of the stark outline and rigid pose.

Dine may have resisted the strong pull toward traditional figurative art in the work he created for his highly visible New York exhibitions of the 1960s, but he did not deny himself completely. Two theater projects and the working drawings he made for them gave him the opportunity to draw in a straightforward manner and to work directly with the figure. In hindsight, one can see how

24. *Running Self-Portrait (L. L. Bean)*, 1964
Oil on canvas and rope, 84 x 84 in. (213.4 x 213.4 cm)
Private collection, London

25. *Bathrobe*, 1965
Etching, 22 x 16⅞ in. (56 x 43 cm)

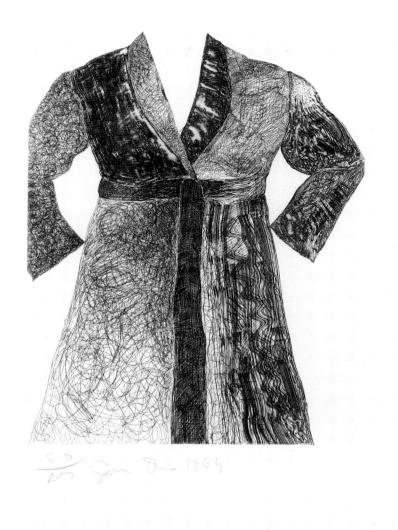

25

Dine's interest in theatrical productions was a logical outcome of his own performance. Having given up performing himself, he chose to play the role of an aggressive designer, defining an entire production through the visual intensity and specificity of his instructions regarding costumes, props, and staging.

During 1966 Dine worked on a new production of William Shakespeare's *A Midsummer Night's Dream* for the San Francisco Actor's Workshop.[17] Dine's thirty-some working drawings incorporate detailed written instructions, including collaged swatches of paint samples that leave no doubt as to his color preferences. Two examples of costume designs, for Theseus and Philostrate, indicate how involved Dine was with every level of detail. Knowing what the impact of costume and staging could be, and knowing that he wanted to create an outlandish production of a classic, he pushed as hard as possible.

The actor playing Theseus, king of Athens, donned a long black velvet coat with silver braids and large pockets. Underneath he 26

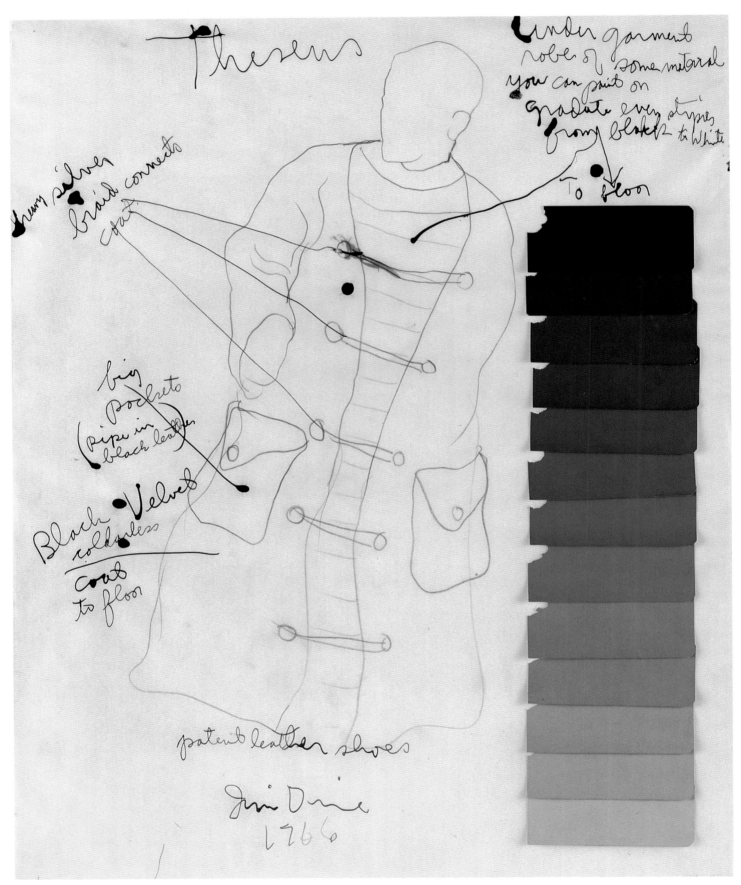

Theseus

under garment
robe of some material
you can paint on
Graduate every stripes
from black to White

shiny silver
braid connects
coat

To floor

big
Pockets
(pipe in
black leather)

Black Velvet
coldurless

coat
to floor

patent leather shoes

Jim Dine
1966

26

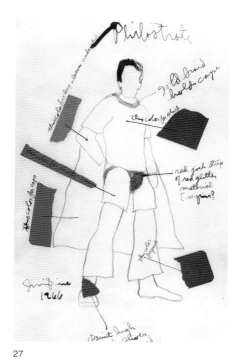

wore a striped robe. The graduated color change in the stripes is indicated by a color bar that is reminiscent of Dine's color-chart pictures. Philostrate had an even flashier costume. A long cape held together by a gold braid reveals a tight-fitting costume with an over-the-shorts jockstrap of red glitter and sequins. In this rendering several torn paint samples festoon the sheet, indicating all the many colors that Dine required.

During the winter of 1967–68 Dine designed the costumes for a stage production of Oscar Wilde's *Picture of Dorian Gray*, which unfortunately never took place.[18] This drama involved fewer characters than in the Shakespeare production but several changes of costumes—for Dorian and Sybil, in particular. This project again gave Dine an opportunity to explore the idea that personalities could be communicated through clothing, and his costumes are visually bold and psychologically revealing. As before, he wrote detailed instructions on each rendering so that there would be no confusion as to his intentions. In place of commercial paint samples, here he collaged clippings from fashion magazines. A large red heart had made its first appearance in Dine's oeuvre the year before as a prop in *A Midsummer Night's Dream:* the character Puck held tight to a stuffed heart that had been suspended from the flies of the stage like a giant swing. A year later the heart reappeared in miniature: a small satin heart with bleeding satin drops was suspended from a gold chain around Dorian's neck—an appropriate accessory for his final costume.[19]

Dine had been dealing with sculptural issues from his environmental installation *The House* to his stage designs and props for *A Midsummer Night's Dream* and his use of objects in studio works such as *Black Bathroom No. 2* and *Window with an Axe*. In fact, one could make a case for calling him more of an object-maker than a painter from the start, and from 1965 through 1967 Dine focused considerable attention on sculpture. Among the works he produced were approximately a dozen aluminum sculptures, plus

26. *Costume Study for "A Midsummer Night's Dream": Theseus*, 1966
Collage, pencil, and pen and ink on tracing paper, 23⅞ x 19 in. (60.7 x 48 cm)
The Museum of Modern Art, New York; Gift of Mrs. Donald B. Straus

27. *Costume Study for "A Midsummer Night's Dream": Philostrate*, 1966
Collage, pencil, felt-tipped pen, pen and ink, and glitter on tracing paper, 19 x 12 in. (48.3 x 30.5 cm)
The Museum of Modern Art, New York; Gift of Mrs. Donald B. Straus

28. *The Picture of Dorian Gray: Sybil Vane in the Park*, 1968
Pasted paper, gouache, acrylic medium, felt-tipped pen, pen and ink, and pencil on paper, 30 x 20 in. (76 x 50.8 cm)
The Museum of Modern Art, New York; The Joan and Lester Avnet Collection

29. *The Picture of Dorian Gray: Dorian Gray's Last Costume*, 1967
Pasted paper, gouache, felt-tipped pen, ink, and pencil on tracing paper, 29⅞ x 20 in. (76 x 50.8 cm)
The Museum of Modern Art, New York; The Joan and Lester Avnet Collection

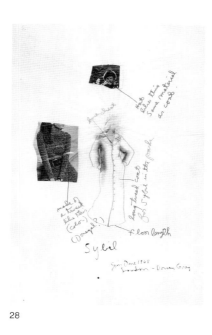

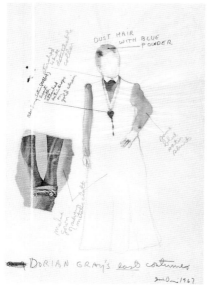

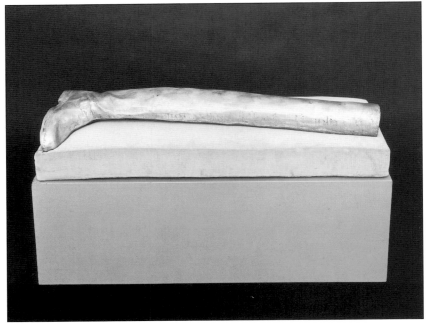

30

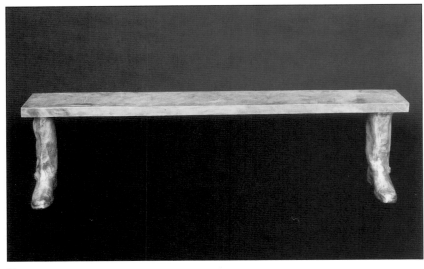

31

a large installation titled *Nancy and I at Ithaca*,[20] which consisted of eight sculpted parts that he had created while teaching at Cornell University during the fall and winter of 1966–67.

30, 31, 98 *Large Boot Lying Down, A Boot Bench,* and *Hammer Doorway* are among the sandcast-aluminum sculptures that Dine made in 1965, some of which he included in his exhibition at Janis Gallery the next fall. These sculptural works are consistent with Dine's previous preoccupation with shoes and tools; now the shoe has become a boot, literally the "leg" of the bench. By increasing the boot's length and placing it on its side, as in *Large Boot Lying Down,* Dine transformed the boot into a body that rests on the lid of an implied sarcophagus.

In *The Hammer Doorway,* the hammers, like the boot, are elongated, so that they are transformed into two columns, with their heads suggesting capitals or the beginning of an open archway. The

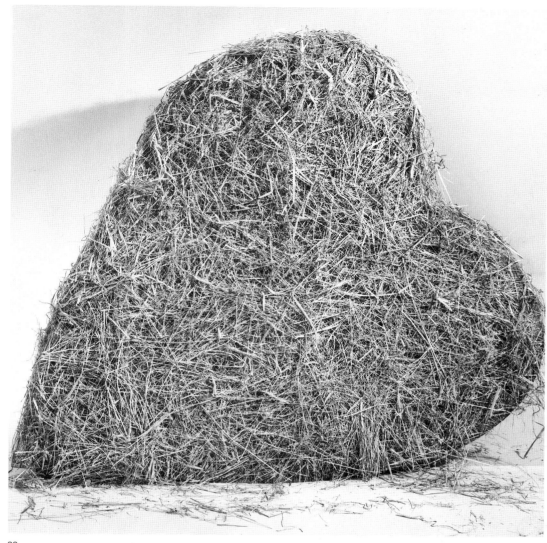

32

32

issue of sculpture as an object of aesthetic contemplation versus a functional object is one that has long been debated. Once a sculpture takes on a function, it is generally "downgraded" to a decorative-art object. *A Boot Bench* and *The Hammer Doorway* make light of such classifications. Now functional objects, boots and hammers, become unfunctional elements of functional sculptures.

The reason *Straw Heart* is dated 1966–69 rather than 1966–67 (when it was first created as part of the *Nancy and I at Ithaca* group) is that Dine reworked its surface in 1969, the same year he created *Five Chicken Wire Hearts (John Peto)*. Both the Ithaca installation and the wire hearts consisted of several objects or parts. The former included lips, a waterfall, a hand, and other shapes. Dine reworked the surfaces of each unit several times, using different colors and different cloth surfaces. Only later, in 1969, did he cover the sheet-metal heart with straw, giving it a tender, somewhat fragile feel. What had begun as a stark, cold metal heart with a silver surface thus ended up as a delicate, resonating heart covered in straw. Once again Dine had altered an image in order to transform its meaning and tap into another vein of its communicative potential.

30. *Large Boot Lying Down,* 1965
Cast aluminum and velvet, 23 x 41 x 15 in.
(58.4 x 104 x 38 cm)
Private collection, New York

31. *A Boot Bench,* 1965
Cast aluminum, 17½ x 71 x 12 in. (44.5 x 180.3 x 30.5 cm)
Private collection, New York

32. *Nancy and I at Ithaca (Straw Heart),*
1966–69
Sheet iron and straw, 60 x 70 x 12½ in. (152.4 x 177.8 x 31.8 cm)
Private collection, New York

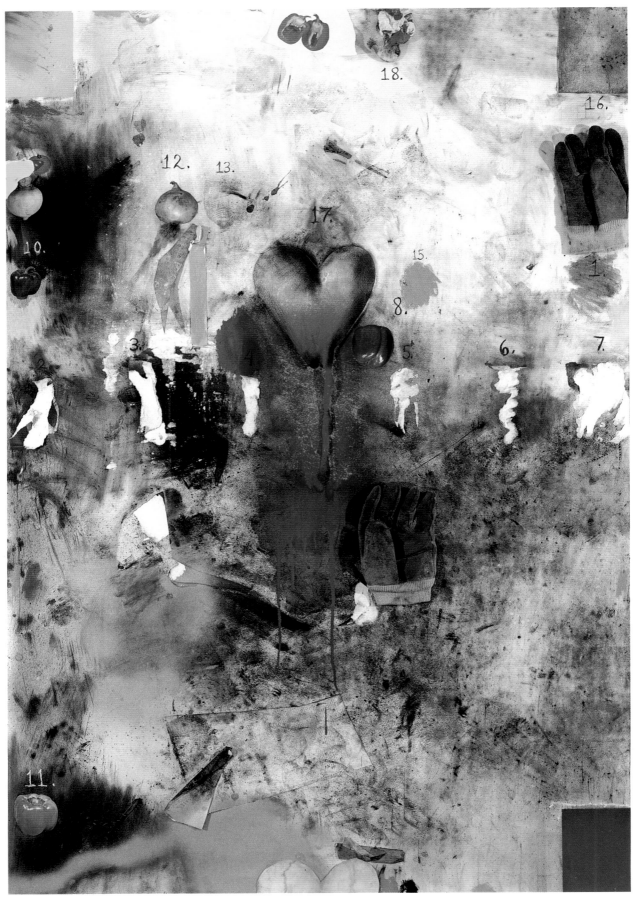

2 The Liberating Lessons of Europe

Dine made his first trip abroad in the spring of 1966, at the invitation of Editions Alecto. His two-month stay in London offered a welcome escape from what he considered an unbearable situation in New York City. Although he had moved from the public arena of Happenings to the privacy of his studio, he could not escape the attention and anxiety of being a Pop star. Despite his outpouring of ambitious and critically acclaimed work and despite having entered psychoanalysis in 1962, Dine had not yet achieved a clear and confident understanding of who he was as an artist and where he wanted to go next with his art.

Therefore, after finishing his teaching stint at Cornell in the spring of 1967, Dine chose to move with his family to London. They remained there until 1971, with occasional visits home, especially during the time of the artist's first major American retrospective—his 1970 exhibition at the Whitney Museum of American Art, which summarized the thirty-five-year-old artist's extraordinary career to date.

London offered Jim Dine a new world in every way. Released from what he considered the tyranny of the New York art scene, he felt free to explore any medium, style, or subject. For a while he turned his attention to writing poetry and published a volume of his poems, *Welcome Home Lovebirds*, in 1969. The following year he collaborated on another book, *The Adventures of Mr. and Mrs. Jim and Ron*, with his friend the writer Ron Padgett. Dine soon abandoned his efforts to become a professional writer, but these publishing ventures mark the beginning of his ongoing interest in illustrating texts. His efforts would turn from commercial publications to collaboratively produced *livre de luxe* editions.[21]

Dine's interest in writing, book illustration, and the kind of precise drawing that he had done for his theatrical projects went hand in hand with a growing interest in printmaking. When visiting Editions Alecto, Dine had met Paul Cornwall-Jones, who established his own workshop, Petersburg Press, in 1968. When Dine moved to London he connected with Cornwall-Jones again, and they began what would be an extraordinarily fruitful seven-year affilia-

33. *Untitled (Gloves)*, 1971
Collage and mixed media on paper with objects, 60 x 40 in. (152.4 x 101.6 cm)
Stuart and Anne Robinowitz, White Plains, New York

tion. Petersburg Press had the capability to produce lithographs and etchings, and by the early 1970s it also had a shop in Manhattan, so that Dine could continue working with them after he returned to the States.

Dine concentrated mostly on poetry and printmaking from 1966 through 1969, but there are a few notable exceptions. During that period he created *Francis Wyndham* (Museum Boymans-van Beuningen, Rotterdam), a large painting named after an English critic and writer; he reworked *Straw Heart* from *Nancy and I at Ithaca;* and he created two large word pictures, known as the Name Paintings. Dine is seen working on *Name Painting (1935– 63) No. 1* in 1969 in a marvelous documentary photograph that appeared in the catalog for his 1970 Whitney retrospective. This word picture, which is 72 by 192 inches, served as a sixteen-foot-long scroll on which Dine wrote the names of all the important personages in his life, from birth until the mid-1960s. He began with his grandfather Morris Cohen and ended with the avant-garde theatrical personality Julian Beck. In between are hundreds of names: childhood friends, numerous relatives, the artists of the 1950s and 1960s, critics, collectors, and dealers.

Making this word picture marked an important moment in Dine's life, as he came to grips with his life in America from the comfortable distance of his Chester Square studio in London. He reviewed the past thirty years through this somewhat compulsive act of recording name after name of those he had once known and knew now. It is one of those rare and powerful summary statements made at a time when an individual is taking inventory and readying himself to move on.

During these London years Dine was ingesting his first dose of European art and culture. In his early days as a member of the New York avant-garde he had been cautious about making any connection in his work to European art history, which his colleagues considered anathema. But when Dine arrived in Europe, his interest in that history was piqued. At first he found the weight of history burdensome and frankly intimidating; he needed to distance himself from Manhattan but was not yet ready to plunge into European culture, and even though he went to Paris for the first time in 1968, he did not enter the Louvre until 1970. This is revealing, for it indicates that the prolongation of his stay in Europe was crucial. Gradually, Dine began to study the art of the past, allowing it to become part of his visual universe, and eventually permitting it to become the acknowledged[22] inspiration for a series of his own.

At the end of his London stay Dine created ten large mixed-media works on paper. These were made as a group and shown as such at Sonnabend, New York, in the spring of 1971. This series was initially inspired by a painting by Francis Picabia, *L'Oeil Cacoylate* (1921; Musée National d'Art Moderne, Paris), which Dine had seen at the Trocadéro in Paris; it includes collaged elements and writing in different styles.

A single eye, though not large, has a haunting presence within Picabia's composition. In all of Dine's Picabia-derived works, including *Untitled (Gloves)* and *Untitled (Tricky Teeth)*, he

replaced Picabia's staring eye with the bleeding or more possibly "crying" heart that he had used in his final costume for Dorian Gray. The heart floats in the top center of each composition, placed where it would be if a standing figure occupied the sheet. The plump red heart in the picture with the glove is a cutout from a lithograph. The deeper purple-gray heart in *Tricky Teeth* was cut from the litho plate itself. In plate 33 the heart is surrounded by a complex array of smudges and markings amidst floating images of vegetables. The tomato, red pepper, and onions were elements used in a series of eight lithographs that Dine had done that year. In explaining their presence here, along with a pair of workman's gloves, he commented, "I thought the real gloves in *Gloves* were particularly poignant because they are stand-ins for hands. The rest of the picture comes from the floor of my studio. . . . I leave things there intentionally, walk on them . . . and maybe pastel dust rubs off on them. I trust accidents, which is why I like what falls on the studio floor, and it becomes grist for my mill."[23]

Dine can't remember why he used the title *Tricky Teeth*, even though he boldly labeled it that with the type of dotted letters that simulate flashing lights. Recalling that he was friendly at the time with the poets Ted Berrigan and Ron Padgett, he now assumes that the phrase was one of theirs and it simply appealed to him. It also conjures up the teeth images that appeared in some of his 1960s works with toothbrush or bathroom subjects. In *Tricky Teeth* the heart (the only representational image in this painting from the series) is set against a color-chart background, and just as the heart bleeds so do the panels of color. The blocks of color have softened, and each blends into the next with long, runny drips that mirror the leakage from the central heart.

Both *Gloves* and *Tricky Teeth* are poignant, poetic pictures in which the heart image is allowed to play a central role, although it is proportionately small in terms of the overall picture size. The heart represents a love that is imperfect (the heart is bleeding), sexual (hand and mouth are connoted by the glove and teeth), and deeply sensual (a quality conveyed by the richly colored backgrounds).

In spring 1971 Dine left London to settle in Putney, Vermont, but he continued to work with Petersburg Press and to create paintings, prints, and drawings that were a logical outgrowth of his London work in subject and tone. Therefore his art did not immediately register his abrupt transition from worldly London to rural Vermont. This is apparent if one looks at plates 34 through 40, which range from the 1970 drawing *Hair*, made in London, to *Piranesi's 24 Colored Marks*, an etching completed in Vermont at mid-decade. A more radical break with his European work came soon thereafter.

The scrawly, scratchy black line that Dine first began using in an early bathrobe became an obsession with sexual intent. In *Hair* the triangle of graphite lines represents the darkest of female pubic hair. Dine's attention turned to his own sex in *Red Beard* and *Souvenir*. The wide paintbrush—the tool of the craftsman-painter and of the artist-painter—and the palm tree are stand-ins for himself and can alternatively refer to two parts of his body. As the title

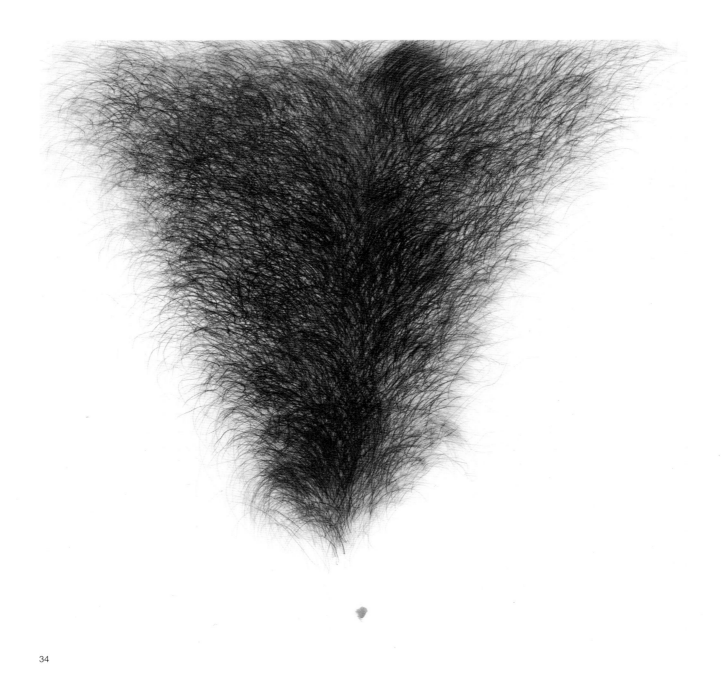

34

34. *Hair*, 1970
Pencil on vellum, 23 x 23 in. (58.4 x 58.4 cm)
Private collection, New York

35. *Piranesi's 24 Colored Marks*, 1974–76
Etching with hand painting in watercolor, 25¾ x
23¾ in. (65.4 x 60.3 cm)

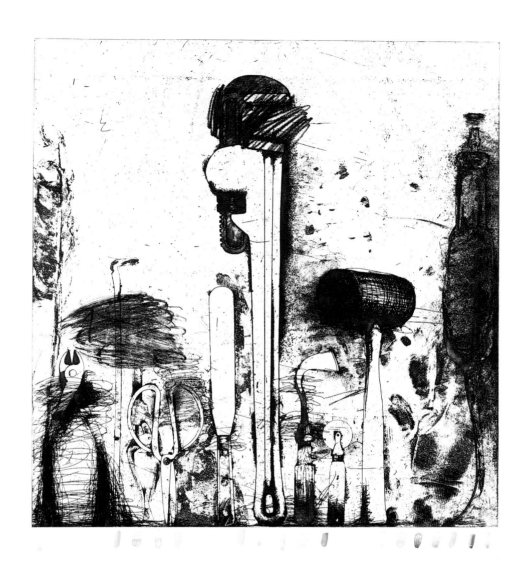

35

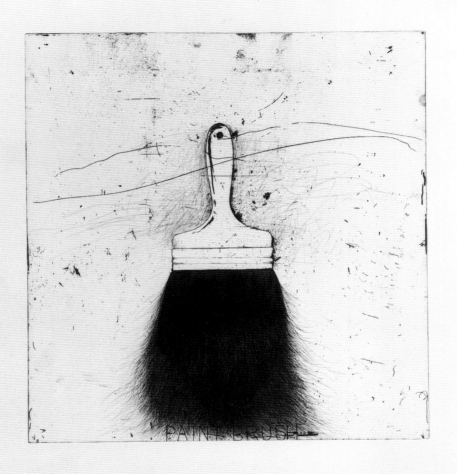

PAINT BRUSH

36

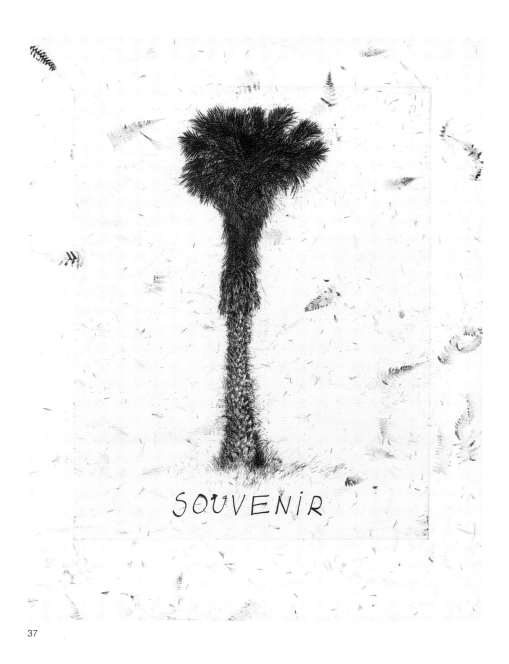

37

36. *Red Beard*, 1973
Etching, 42 x 30 in. (106.7 x 76 cm)

37. *Souvenir*, 1974
Etching, 30 x 22 in. (76 x 56 cm)

indicates, the brush conjures the hair of the long beard that he grew during this period. And the brush and the palm tree can both be interpreted as metaphors for his sexual organ, sprouting from its surrounding pubic hair.

A sexual interpretation of these images has been avoided in most of the literature on Dine; instead it is the masterful etching technique that has been touted. But the power of these prints comes from the merging of his virtuoso use of the etched line with his transformation of such common objects. Hundreds of strands emanate from the handle, merging into a mysterious blackness; at the edges some separate into wispy curls. Their suggestive softness and the softness of the background (achieved by not wiping the

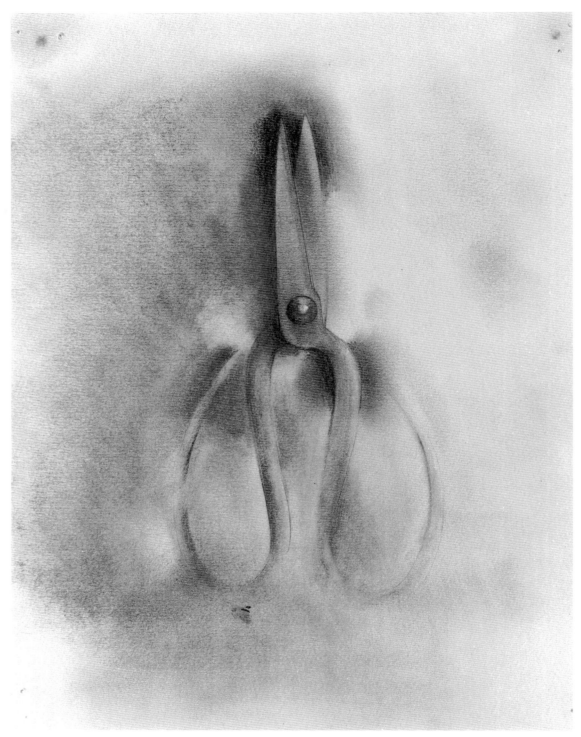

38

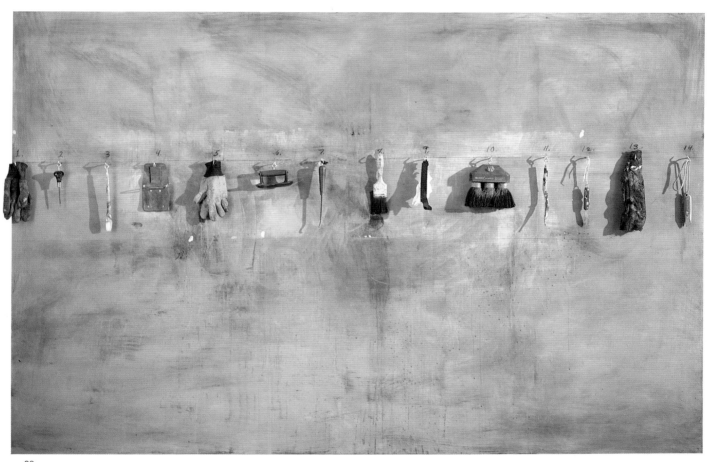

39

38. *Fifty-two Drawings (for Cy Twombly),* 1972
Pencil on paper, 8¼ x 6¼ in. (21 x 16 cm)
Mr. and Mrs. Bagley Wright, Seattle

39. *Our Life Here,* 1972
Oil and objects on canvas, 60 x 96 in. (152.4 x 243.8 cm)
Private collection, New York

plate, with its random scratches, quite clean) combine to create an effect that moves viewers no matter how limited their knowledge of printmaking processes may be.

By his own admission, Dine hit his stride in printmaking with his early 1970s tool prints, including *Red Beard* and *Souvenir.* His ability to draw on the plate was developed through working on paper as well. He explored the single tool, one per sheet, in a series entitled *Fifty-two Drawings for Cy Twombly.* In 1971, after he had settled in Vermont, Dine went down to Manhattan, and while doing the gallery rounds, he saw a group of small ballpoint-pen drawings by Twombly at the Leo Castelli Gallery. Dine's response to them was so strong that he said instantly to Nancy: "Let's get out of here. I'm going back to Vermont to work." And that he did,

38

taking about a year to complete the fifty-two works.[24] Dine's recounting of this episode suggests a variety of points: he was inspired by the draftsmanship of one of the day's prominent figures; he simply wanted to draw and draw better; and once he was away from his Vermont studio, even briefly, he was overcome by the urge to flee, to get back to work.

These fifty-two tool drawings and the many others that he made during the early 1970s are the culmination of Dine's prolonged homage to these instruments, which he transformed into devotional objects. Dine traced the tool profiles as if each were a stencil and then elaborated them with shading; he now labels them "dumb" and "straightforward" compared to his later draftsmanship. (His negative hindsight is that of an artist who always prefers what he is doing now over what he did in the past.) Nonetheless, these tools possess life. Each one was rendered with loving care, suspended against a softly textured background. Hung in a large group, the drawings and, by extension, the tools become a valued collection. The tools are no longer plebeian instruments but a treasure trove of prized possessions.

Dine took the idea of collecting and lining up tools as the starting point for another type of tool composition. Instead of having one image alone, or hanging together many sheets, each with a solitary image, he combined numerous tools within a single composition. The artist used this approach in drawings, prints, and some of his first paintings in Vermont.

39 *Our Life Here* is a specific reference to the artist and his family's new home in Vermont. Real tools and gloves are suspended in a straight row along the implied horizon line of a shadowy brown backdrop—like the tools displayed in the stores of his childhood. Each element is numbered, as are the images in his Picabia-inspired collages. Dine was taking inventory, carefully lining up and counting the objects of his affection. He has referred to this picture as a list of the source materials with which he works.[25] From them he derives his inspiration, so much so that they become the symbols of "our life here."

40 Drawn and etched tools replace the real ones in an untitled collage and in *Piranesi's 24 Colored Marks,* both of which also function as "lists." In the latter work, in particular, the tools are crowded together, like jealous siblings or classmates all wanting a central place of honor when their picture is taken. They stand proudly erect, bathed in Dine's subtle lighting or abruptly obscured by his indulgence in fits of bravura etching technique. The density of the black-and-white linear composition conjures the complex renderings of Piranesi, hence Dine's offer of homage through his title to this master draftsman and printmaker. By doing so, Dine also acknowledged the increasing impact that his study of art history was having on his art, indicating that even while he made his home in rural Vermont he was eagerly looking toward Europe for instruction and inspiration.

40. *Untitled*, 1973
Graphite and collage on paper, 23 x 30½ in.
(58.4 x 77.5 cm)
Private collection, New York

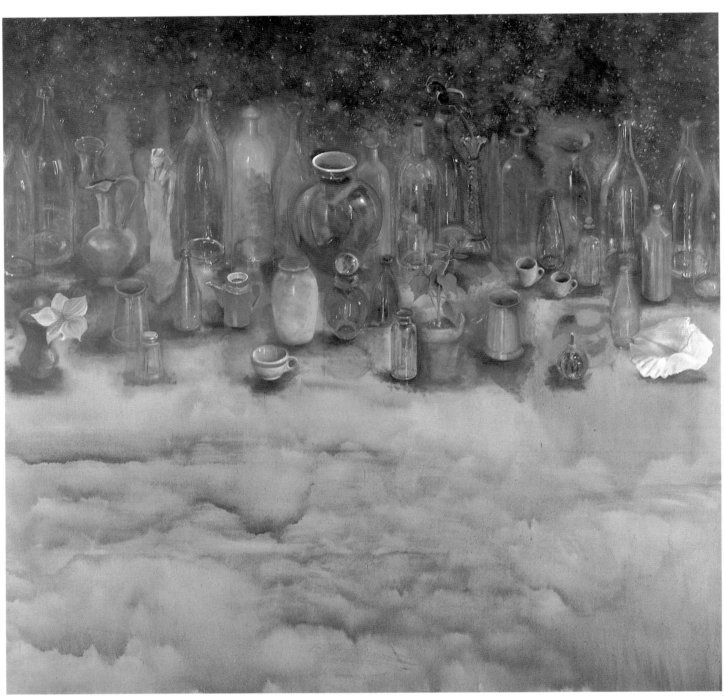

3 Renewal Through Figure Drawing

In 1974 Elan Wingate from the Sonnabend Gallery in New York shipped two department-store female mannequins up to Vermont. Their arrival, along with the hiring of local models, marked Dine's immersion into figure drawing, a preoccupation that would last for several years and have an impact on much of his art in the following decade. Dine felt that while he would have been pleased to have his just-completed tool drawings represent his drawing skills, he recognized that another level of achievement was possible and he started to strive for it.

Encountering the history of representational art in Europe gave Dine the opportunity to observe at first hand the great European art not only of the distant past but also of recent decades. As a result, he realized that the nineteenth- and twentieth-century art that attracted him most was not work by early nonrepresentational artists such as Wassily Kandinsky, Kasimir Malevich, and Piet Mondrian but representational images by Paul Cézanne, Henri Matisse, Vincent van Gogh, André Derain, Edvard Munch, Alberto Giacometti, and Balthus. The still youthful artist came to realize that he could connect with a modern tradition *and* follow his inclination toward representation. This path took Dine away from the New York avant-garde—both the well-established Abstract Expressionists and the newly ascendant Minimalists and Conceptualists—but led him to an aspect of recent art history that was more highly valued in Europe than America: modern figuration.

For Dine, drawing tools was easy compared to drawing figures. He began with the mannequins, perhaps thinking that they would serve his purpose because, like tools, they were inanimate; he would make them come to life. Dine did work from the mannequins and from photographs (from British *Vogue* and elsewhere), but the technical ability that he acquired in the mid-1970s came after hours and hours of drawing directly from the model.

The significance of this period of self-imposed education is considerable. According to Dine, he was now buckling down and finally getting serious as an artist. (This unnecessarily harsh critique of his early years should be considered as the comment of a forty-

41. *The Night Forces Painterliness to Show Itself in a Clearer Way,* 1978
Oil on canvas, 96 x 96 in. (243.8 x 243.8 cm)
Private collection

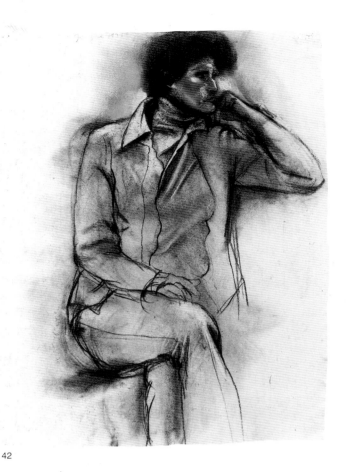

42

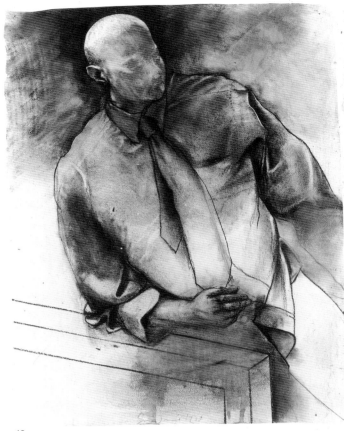

43

year-old who had reached another turning point.) He was ready to become a student again—an adult student this time. He engaged in the age-old academic practice, which he had shunned as a student of Kaprow's: day after day he would draw from a live model, teaching himself to see the world anew and developing the eye-to-hand dexterity that only patience and repetition can bring. Through this self-imposed, highly disciplined exercise, he became a master draftsman and created dozens of drawings that would become the core of several exhibitions during this period.

Most of the drawings are on sheets of paper that measure about thirty by forty inches. Usually a single figure dominates the page. Each is worked in a combination of media, including charcoal, pastel, crayon, and oil. Two works from the very beginning of this fertile period make a distinctive pairing, although they were not originally created as such: *The Russian Poetess* and *Cher Maître.* Dine did group them with six other drawings and use them for a suite of eight etchings printed in 1976 and titled *Eight Sheets from an Undefined Novel.* Both are of relaxed, clothed figures, one male and one female. Their titles conjure the literary associations that the name of the portfolio verifies. Each plays a part in a story that remains untold.

A photograph of a real Russian poetess, a friend of the poet Mayakovsky's, inspired Dine's version. He reworked the source image to such an extent that only the nose hints at the subject's

42. *The Russian Poetess,* 1975
Charcoal, oil, and crayon on paper, 39¼ x 29¼ in. (99.7 x 74.3 cm)
Private collection

43. *Cher Maître,* 1975
Charcoal, oil, and crayon on paper, 40 x 29¾ in. (101.6 x 75.6 cm)
Private collection

44. *The Cellist,* 1975
Charcoal, oil, and crayon on paper, 39¾ x 29½ in. (101 x 75 cm)
Private collection

45. *Two People Linked by Pre-Verbal Feelings,* 1976
Charcoal, oil, and crayon on paper, 39¾ x 29¾ in. (101 x 75.6 cm)
Private collection

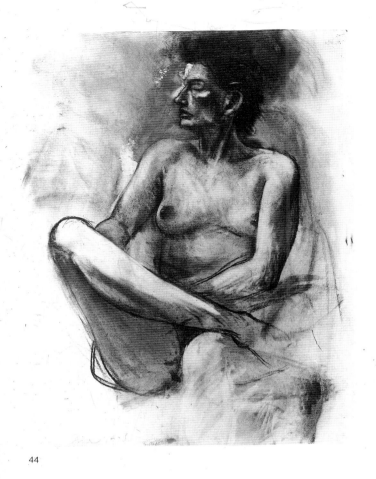

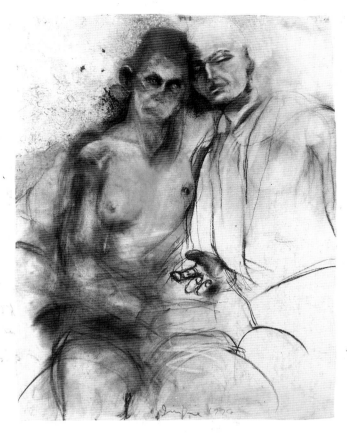

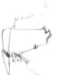

original Eastern European profile. Now she is a modern woman, clad in slacks and layered shirts. Every line, every smudge, every passage of darkness or highlight contributes to the confidence of her relaxed pose and the intensity of her concentration.

Much the same can be said of *Cher Maître*, although here the subject's facial features remain undefined and his gaze is turned away from the viewer. Thinking back to Dine's tie images, one notes a striking difference between those crudely rendered symbols of masculinity and this academically accurate depiction of a virile, broad-shouldered gentleman in fashionable shirt and tie.

Also in *Eight Sheets from an Undefined Novel* is a drawing of a female nude identified as *The Cellist*. The drawing style, composition, and relaxed pose relate it to the two just-mentioned works. The cellist's silhouette is sharply outlined, and the contours of her neck, small breasts, and long slender calves are rendered through tonal variations. As in many other of his drawings from this period, Dine could not contain his exuberant love of his materials and marks; as he moved toward the edge of the paper, beyond the boundaries of the figure, his gestures ceased to serve a descriptive function and veered toward expressive abstraction.

In two other drawings from the same time[26] Dine shifted from the single figure isolated on a page to a different format: two figures shown side by side, engaged in emotional dialogue. In the earlier of the two drawings, *Two People Linked by Pre-Verbal*

44

45

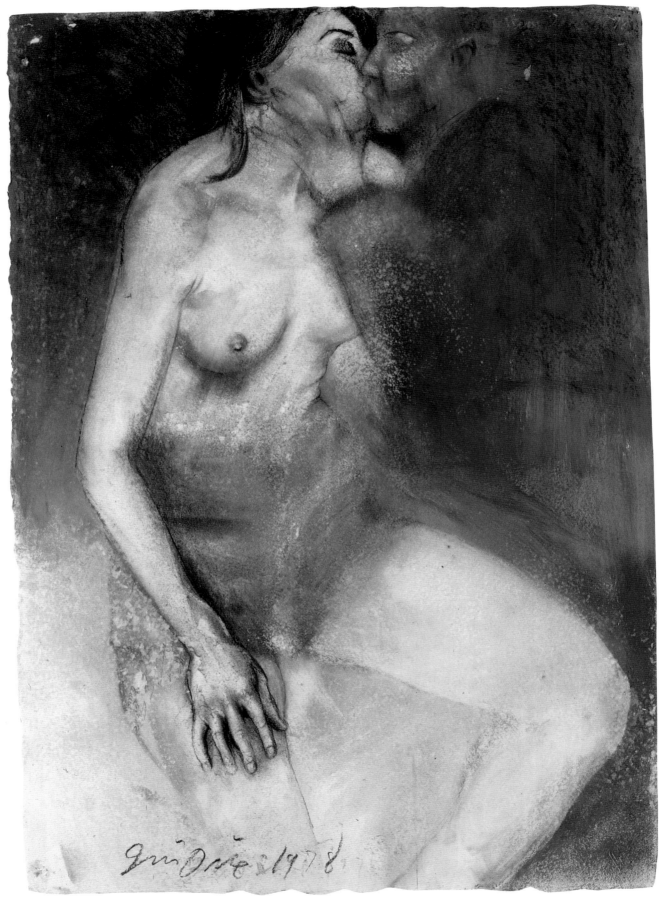

46

Feelings, a nude female looks out at us even though she is locked in an embrace with a clothed male. Their heads touch, and their upper torsos press against one another. Their expressions suggest thought and feeling, not dialogue—just as the title suggests; they are linked by a deep emotional exchange. The female figure is the focus, the model. She is turned toward the viewer, toward the artist so he can still study her. The same can be said for *A Study of Kissing*, in which a nude female turns only slightly toward her lover so that her sexually charged torso faces us. The viewer looks first at the top of the sheet, at the actual act of kissing, but the sexual energy in this drawing comes from the description of the woman's nude body. Her bare breasts, the way her lower body moves into mysterious darkness, and the placement of her hand on her upper thigh all contribute to an intense eroticism. The body of her companion is in shadow.

A drawing from this period that Dine did not complete until the end of the decade, *The Sitter Progresses from London to Here in Three Years*, shows clearly how labored his drawing process had

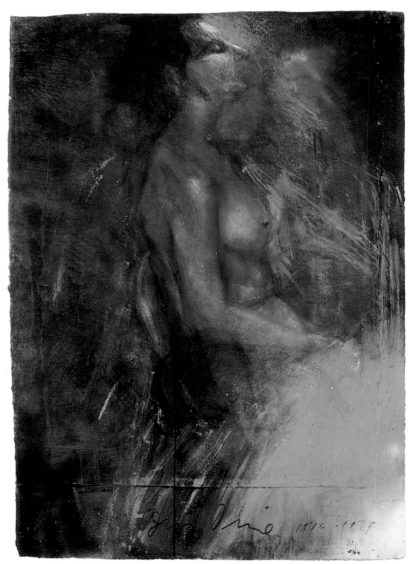

46. *A Study of Kissing*, 1978
Pastel, charcoal, oil, and turpentine wash on paper, 41½ x 31¾ in. (105.4 x 80.6 cm)
Private collection

47. *The Sitter Progresses from London to Here in Three Years*, 1976–79
Pastel, oil pastel, charcoal, and acrylic gesso on paper, 41½ x 31¾ in. (105.4 x 80.6 cm)
Private collection/, New York

47

become. Labored not in the sense that it appears heavy-handed, but labored in the sense of having been worked and reworked until the sheet contains a complex history of the artistic process. Dine created his drawings by erasing and rebuilding, and erasing again and rebuilding again until the drawing was layered with texture. The evidence of the process becomes part of the content. As the drawing's formal complexity and visual variety increases, so does its emotional depth. This seated figure is not just a model in the studio rendered in an ordinary pose. She is a mature, seductive woman clouded in a mysterious darkness, at the same time that she is confronted by an external light. A shock of pink highlights her cheek. Because the majority of the sheet is dominated by dark tones, our eye is led to her blushing face. This emphasis leaves us wondering whether she is in the throes of some emotional upheaval.

Dine originally started drawing in 1974 as an exercise, not intending to create finished, exhibitable works of art. Once it became clear that he was doing just that, he started putting his drawings on view. Perhaps because they were quickly dispersed to collectors, perhaps because critics saw them as unimportant compared to his paintings, or perhaps because of the ongoing prejudice against figure drawing, they continue to be overlooked even now. Yet these figure drawings and his many other large-scale drawings from the 1980s are among the artist's greatest achievements. Through them, Dine redefined himself as an artist both technically and spiritually. Through them, he combined his highly developed visual awareness with a new level of expressive energy.

Dine recalls having made descriptive self-portraits as early as 1957, but the pressure of the avant-garde spirit soon pushed him to abandon this approach for symbolic portraiture. It was through printmaking and drawing that he first allowed himself to break free from the limits of artistic acceptability. Beginning in 1971, again upon his return from Europe, Dine started drawing his own likeness, first in drypoint and then, by 1974, in intaglio.[27] During his mid-1970s education as a draftsman, he not only worked from female models but also turned to the mirror. The figure drawings make it evident that Dine's approach was one of intense observation; the self-portraits document this acute scrutiny. Dine's reflection looks back at us with the same concentrated gaze that he used to study the world around him. *Self-Portrait with Red Ear* was made at the same time as *Eight Sheets from an Undefined Novel.* It is a small work, only thirteen and one-half inches by ten inches; because Dine compacted a lot of visual data into this small format, the sheet's size is not a limitation but a means toward a potent vision. Dine's expression is extremely serious, with his brow furrowed, his lips tensed. The intensity of his visual concentration is unmistakable.

Over the years Nancy Dine has been subjected to the same scrutiny that the artist applied to his own visage. Early portraits testify to her role as a readily available model.[28] When Dine started drawing in 1974, he began with portraits of Nancy, and when he drew his own countenance on a metal plate during the early 1970s, he also etched his first tentative portraits of his wife.[29] It was later in the decade, during the time of his Harvard self-portraits, that he

48

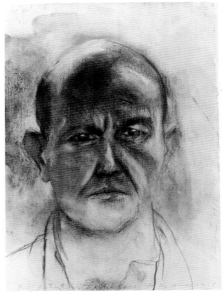

48

48. *Self-Portrait with Red Ear,* 1975
Watercolor, pastel, and charcoal on paper, 13½ x 10 in. (34.3 x 25.4 cm)
Private collection, New York

49. *Nancy Outside in July II,* 1978
Etching and soft-ground etching, 35⅝ x 24⅛ in. (90.4 x 61 cm)

50. *Nancy Outside in July VIII,* 1980
Etching, soft-ground etching, drypoint, engraving, and electric tools, 29¾ x 22¼ in. (75.6 x 56.5 cm)

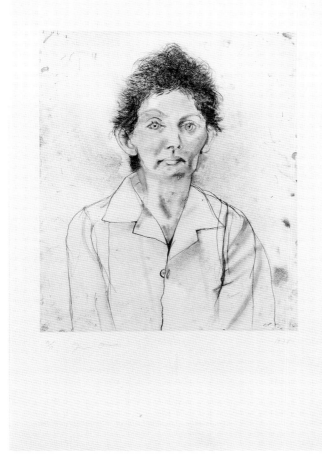

49

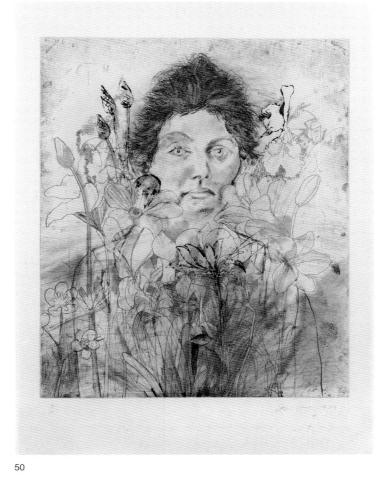

50

launched one of his most ambitious printmaking projects: an evolving portrait of Nancy Dine that would become known as *Nancy Outside in July*. This twenty-five-print series began with a simple drawing in soft-ground on a copper plate. Over a five-year period, from 1977 to 1981, it developed into a tour de force of printmaking technique and experimentation. With great emotional range, from extreme tenderness to raging anger, Dine reinvented again and again the image of his constant companion.[30]

The original soft-ground drawing now seen in the second state 49 relates to Dine's *Self-Portrait with Red Ear*. Nancy sits passively, a model at ease with her role, yet also with ears that are a bit over-accentuated and eyes that are too intense. Dine's interpretation of Nancy is softer and less harsh than the glare of her own gaze would suggest; his drawing is delicate and tender. By the eighth 50 state, Dine allowed this original hint of affection to literally blossom. Nancy's upper torso is now obliterated by a profusion of flowers that rise to caress her face. The large bouquet of flowers includes many types, each accurately and gracefully drawn on the plate with the same attention to detail evident in the face. Whether the flowers should be seen as attributes of Nancy herself, an avid gardener, or as more generic symbols of love or sexual desire, Dine used them to add an overlay of meaning to a descriptive linear rendering.

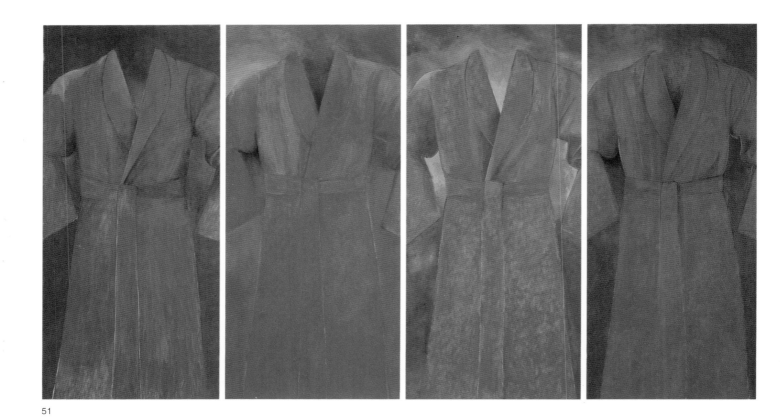

51

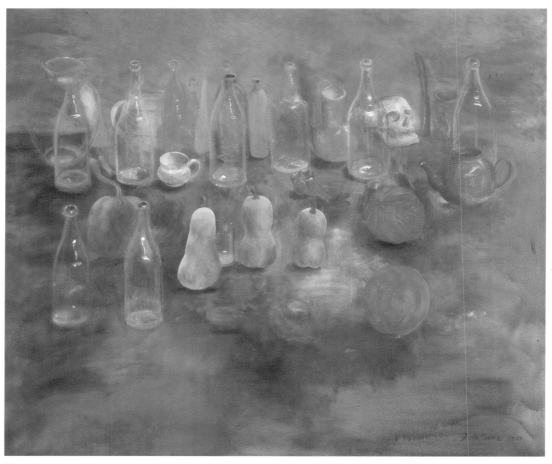

52

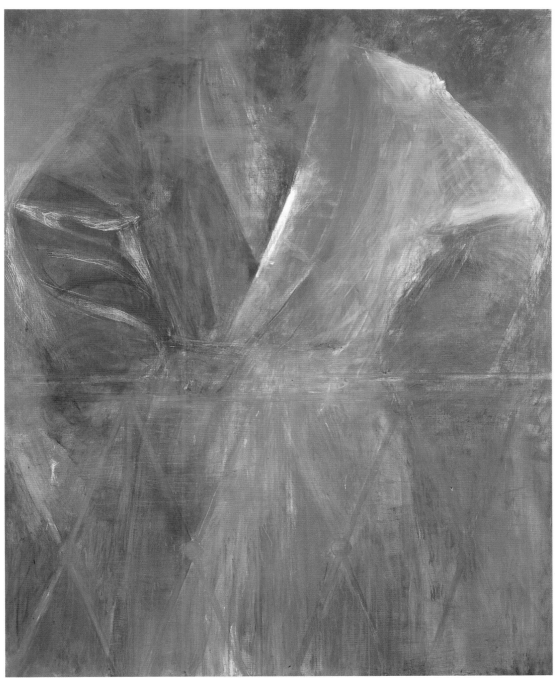

53

51. *Four Robes Existing in This Vale of Tears,*
1976
Oil on canvas, four panels: 80 x 36 in. (203 x
91.4 cm), each
Mr. and Mrs. Scott Summers, San Francisco

52. *The Still Life with a Red Pepper as October
Changes Our Valley,* 1977
Oil on canvas, 72 x 84 in. (182.9 x 213.36 cm)
Private collection

53. *Balcony,* 1979
Oil on canvas, 102¼ x 81 in. (259.7 x 205.7 cm)
Private collection

In 1975 Dine ended his fourteen-year affiliation with Ileana
Sonnabend and soon thereafter joined Pace Gallery. By the time he
was ready for his first Pace exhibition, in early 1977, he had cre-
ated an entirely new body of work that distanced him from all Pop
associations and from the first stage of his artistic development,
which had been summarized in the Whitney retrospective in 1970.
With three New York exhibitions—in early 1977, the spring of
1978, and early 1980—Dine would present a radically different
sensibility that redefined his artistic persona.

These three exhibitions were dominated by two bodies of work: a group of robe pictures and several large still-life paintings. With the former Dine reinvented an image from the 1960s that he had left behind when he went abroad. And with the latter, a traditional artistic form, he reinforced in a totally new way what was already well known about him: his veneration of the object.

Dine began to investigate the robe again at the same time that he was drawing so conscientiously from the figure. For reasons never quite explained he resisted (at this time) painting the female figure. Even though his drawings of the female figure were large and lent themselves to the transformation from paper to canvas, as Dine's desire to paint resurfaced, he elected to return to the empty male robe. He now filled the robe pictures less with the specific attributes of his own personality than with a generalized atmosphere and aura based on his new technical facility in drawing and his increased sensitivity to the properties of light and color.

1 The title of one of the first robe paintings from this period, *Cardinal*, suggests the origin of the flamboyant red against a green background. Dine referred to it as "a glowing object in a field,"[31] a reference perhaps to the flash of red glimpsed as a male cardinal darted in and out of the dull green of his winter Vermont landscape. Here the red has become the defining property of a robe taller and thinner than before but still without an occupant. Dating to the same year, 1976, is Dine's four-panel tour de force of

51 expressive figuration, *Four Robes Existing in This Vale of Tears*. This work, along with the others in Dine's 1977 Pace exhibition, earned Robert Hughes's praise as "the most authoritative images Dine has yet produced," and he called the artist "a more somber painter and a more ambitious one."[32] Hughes welcomed the fact that the whimsy of Dine's earlier work as well as the flatness and lack of resonance that characterized the earlier robes had been replaced by a warm glow, due in part to the way he manipulated oil paint. Both of these works have a meditative seriousness that was new to Dine's oeuvre. Whether shimmering with an intense red, as *Cardinal* does, or standing in the melancholy light of a "vale of tears," these robes pulsate with human breath.

Dine continued painting robes throughout the decade, and as he did so his use of the brush as a drawing instrument became more apparent. Taking his lead from Edouard Manet's *Balcony* (1869;

53 Musée d'Orsay, Paris), Dine painted a robe that, even though it was empty, "stood" alongside a balcony. It hovers in the shallow space that all of his full-frontal images inhabit. One is uncertain if this is a red robe, for the evening darkness prevents us from seeing the robe's true color as it merges and dissolves in the twilight.

The same somber, meditative quality that emanates from these mid-1970s robe paintings permeates all of Dine's still-life pictures of the same period, usually of the dozens of glass and ceramic jars and bottles that the artist had accumulated. Mixed in with these are an occasional teapot, an odd vegetable or two, a conch shell, a skull, and small reproductions of Egyptian or classical statuary. The objects hover in a shallow landscape; there is no secure tabletop. Their physicality is as tenuous as the mysterious haze from which they emerge. The effect is almost of a dream space in which

images emerge from unconsciousness only briefly before the morning light causes them to slip away.

Dine gave these pictures titles that offer the viewer clues to his intentions. *The Still Life with a Red Pepper as October Changes* 52 *Our Valley* is permeated with the sadness of autumn, that moment when the intense summer light and heat give way to the melancholy associated with the coming of winter. Heavy acorn squashes and plump orange pumpkins dominate the foreground. Amid the transparent empty bottles is a white skull—a subject that Dine was to concentrate on in the near future. Here it is nestled in with the other objects, a symbol of the fragility of life. The skull can be identified with winter as the season representing life's end or, more simply, as a traditional element in still lifes, linking Dine to his predecessors.

That Dine's objects appear to be slipping from view in an ungraspable, intangible space is even more apparent in *The Night* 41 *Forces Painterliness to Show Itself in a Clearer Way*. In the foreground, objects are easily discerned: the glistening translucency of the bottles' curves, the sensuality of the shell's opening, the overall sparkle of the entire group. At the same time, objects float in a tenuous middle ground. They are struggling to maintain a stable position in that narrow window of light that exists before the night's blackness takes them from us. The fragility of our hold on this vision—on any vision—turns into a poignant metaphor for the tenuous grasp we have on worldly existence.

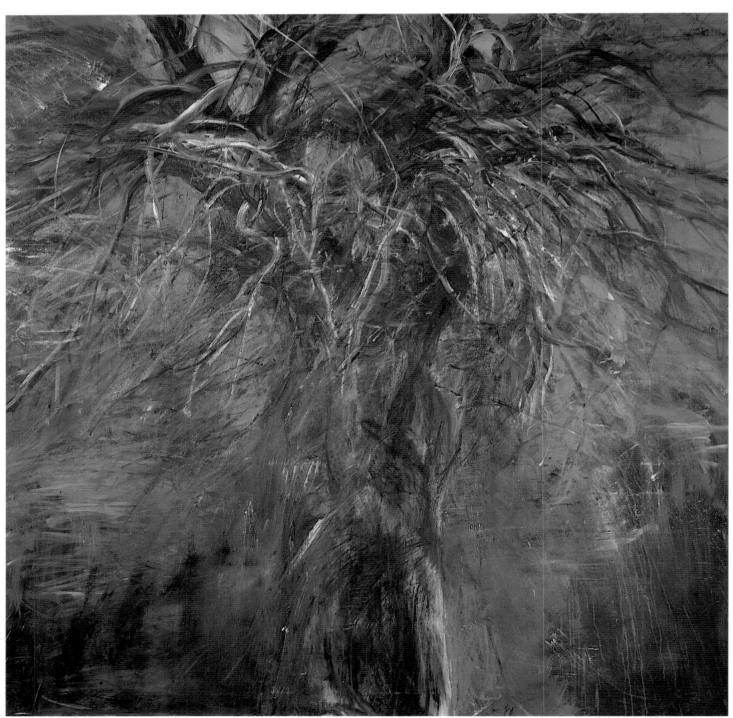

54

The Landscape Expands

There are secondary themes in the art of Jim Dine that are always overlooked, perhaps due to the power of his central themes. One of these is landscape. It would be easy to survey the artist's entire oeuvre and come up with dozens of images that either are explicitly landscapes or suggestive of such. Among the landscapes illustrated just in this volume are the mixed-media *Lawnmower* from 18 Dine's 1962 summer in East Hampton and the *The Studio (Landscape Painting)* he created the next year, which also places found 55 objects against a painted backdrop. Glasses, bottles, ashtrays, and coffee mugs—the objects that somehow always seem to accumulate on the work surfaces of an artist's studio—have here replaced the mower, that symbol of suburban living. The still-life elements are gathered together in *The Studio* and placed on a ledge that extends out from one of the backdrop's six panels. Each panel presents a type of landscape, signified by a flat, allover pattern. Moving from left to right, we have the brown of a muddy field, a rainbow, a night snowfall, lush greenery, the yellow of a brilliant sun, and a turquoise sky. Dine has thereby classified and coded the different landscape types. With surprising directness this early picture offers numerous views from the artist's studio window.

After Dine's move to Vermont, landscape took on a renewed strength in his work. For anyone who has spent much time in Vermont, *Our Life Here* conjures up the state's so-called fifth season: 39 the mud season. The first thaws turn everything soft and brown, long before any hint of spring greenness has an opportunity to appear. Dine created another ode to that welcome greenness in *The* 56 *Art of Painting No. 2*. This five-panel work of 1973 is dominated by tall green grasses reaching up to clear blue skies. Hung overhead are the artist's faithful friends, tools ranging from paintbrushes to garden trowels.

Many of the 1970s figure drawings, which are generally associated with the private indoor world of the artist and his model, still connect with the outdoors. Dine worked the backgrounds with soft blues and the hazy moody light of twilight so they took on the feel of having been worked en plein air, although one senses that is not

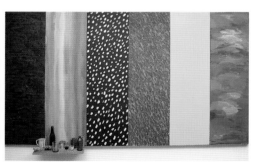

55

54. *A Tree in the Shadow of Our Intimacy,* 1980
Mixed media on canvas, 82½ x 84¼ in. (209.6 x 214 cm)
Private collection

55. *The Studio (Landscape Painting),* 1963
Oil and acrylic on canvas with wooden tray with glass and metal objects, six panels: 60 x 108½ in. (152.4 x 275.6 cm), overall
A. Alfred Taubman, Bloomfield Hills, Michigan

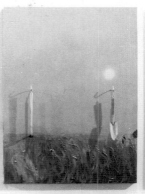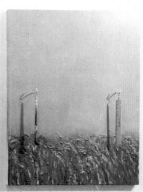

56

really the case and recognizes these as studio-derived studies done from the model. The same suggestion of outdoors is even more dramatically apparent in the mid-1970s robe pictures and still lifes. Dine bathed his surrogate self in a variety of lights so that each conveys a different landscape setting. And his accumulated objects rest not on a studio table but in an outdoor landscape of the artist's own creation.

It was in 1980 that Dine first allowed landscape to move from being a secondary character to the lead role. The Putney landscape is graced with many apple trees, and Dine regularly walked past one in particular. After his son Jeremy photographed it, the artist had the photograph enlarged, then pinned it to his studio wall. For a time he struggled with the image, working directly from the photograph, then in frustration he abandoned this visual aid. Once he relied on memory alone—memory invested with his emotional attachment to the tree—Dine arrived at a new theme: a leafless apple tree characterized by a linear tangle of gnarled, aged branches.

There were, of course, precedents in his work for this image—notably in his prints, the medium in which Dine allowed himself the greatest freedom to be a representational artist. There are two

37, 57 important tree prints: *Souvenir* and *Pine in a Storm of Aquatint;* in each, a single tree dominates the sheet. The later etching, printed just two years before Dine made his first tree painting, foreshadows much of what is to come. He worked on a large scale and exploited the expressive power not only of the image itself but also of its surroundings. The mottled background becomes the "storm" of aquatint as wind and rain whip through and around the sturdy pine.

54 *A Tree in the Shadow of Our Intimacy* is a painterly version of *Pine in a Storm.* Unmistakably a painting, it is also unmistakably indebted to Dine's now confident and highly expressive draftsmanship. The branches of the tree are a tangle of black and white lines forming a confusing web of tendrils that merge with the blue and black background. The age and the shape of the apple trees have an inherent melancholy, giving the picture a heavy sadness. Dine has intensified this effect by using a brush stroke full of tension and by setting the tree against a background of night blackness.

56. *The Art of Painting No. 2,* 1973
Acrylic and collage on canvas, five panels: 48 x 36 in. (122 x 91.4 cm), each
The Art Museum, Princeton University, Princeton, New Jersey

57. *Pine in a Storm of Aquatint,* 1978
Etching, aquatint, and drypoint, 66 x 40 in. (167.6 x 101.6 cm)
Edition of 45, published by Pace Editions

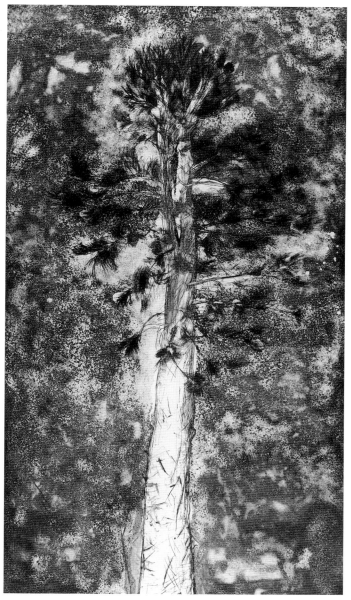

57

Dine created many tree paintings, drawings, and prints during the early 1980s. Each exploits to different effect the expressive potential of the trees' sinuous forms. Just as the linear elements of the hairs in a Dine paintbrush could become sexually suggestive, so the spidery webs of the tree branches reach out with almost frightening allure. The diptych *Red Tree, Flesh Tree, a Carnival* 58 *Tree: The Painting* is composed of two trees. The larger dominates the right panel but also reaches over onto the left, where a smaller tree is easily overlooked. The primary tree is a brilliant blood red, and like the robe in *Cardinal* it is set against a muddy green field. 1 The smaller tree functions as the larger one's shadow or dwarfed companion. Both have a human presence. One seems hot, fiery, and full of sexual presence; the other, drained of its life force, pale and frail. Like Dine's robes, the trees are large, full forms that dominate the canvas's shallow field, pressing out from the foreground,

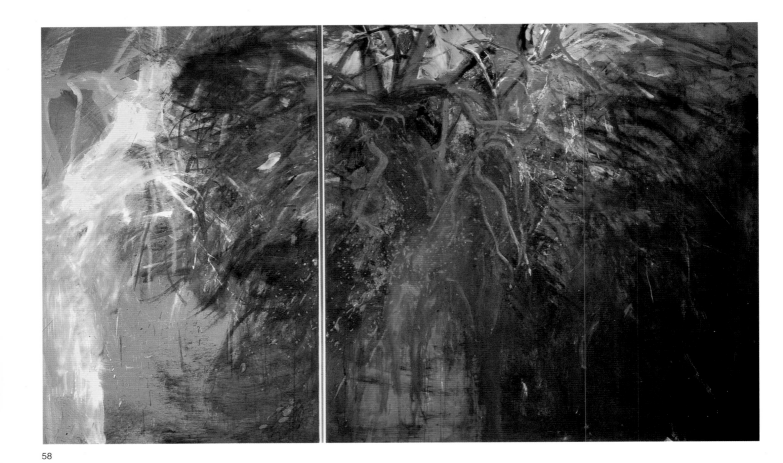

58

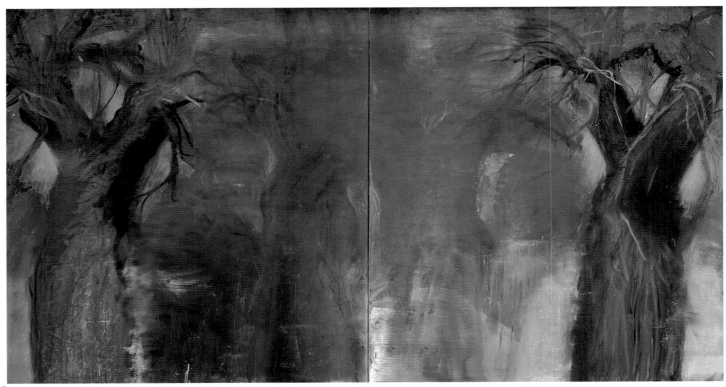

59

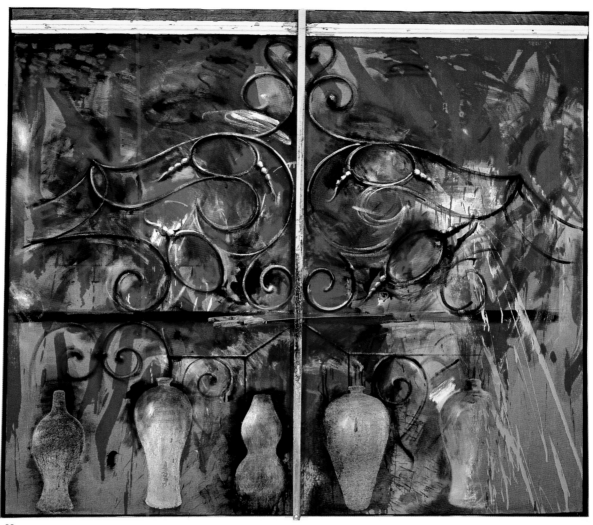

60

almost entering our space, just barely restrained by the picture plane.

The dedication in the title of another tree diptych, *A View in Sologne (for Pep and Aldo),* is a reference to Dine's friends the master printers Pep and Aldo Crommelynck, who have a home in Sologne, France. Dine refers to this picture, which he made in New York as he was thinking of his friends in Sologne, as "a handshake across the sea for them."[33] The outer edge of each panel is occupied by a tree; they are less like the sensuous apple trees of Vermont and more like the solid oaks that Dine had observed in Windsor Park that past autumn. Strong, bulky forms with great mass and weight, they convey a sense of history and stability. The viewer's eye jumps back and forth between them, slowly becoming aware that the primary emphasis is on the large middle space, a shadow-filled vastness, that is "sea" between them.

Part of the motivation behind adapting the tree image was Dine's desire during the 1980s to investigate new subjects. He felt pressed to expand his visual vocabulary. In 1981, a year after he began making the trees, he started exploring the form of a French wrought-iron gate. As in the past, he worked from a found

58. *Red Tree, Flesh Tree, A Carnival Tree: The Painting,* 1980
Oil on canvas, two panels: 84 x 137¾ in. (213.4 x 350 cm), overall
Private collection, New York

59. *A View in Sologne (for Pep and Aldo),* 1980
Oil on canvas, two panels: 84 x 152 in. (213.4 x 386 cm), overall
Private collection, New York

60. *The Crommelynck Gate (Chinese Pottery),* 1983
Mixed media on canvas, 76 x 84 x 4½ in. (193 x 213.4 x 11.4 cm)
Private collection

image—in this case, the gate outside the studio-dwelling of Aldo Crommelynck. For many years, starting in 1973, Dine had been accustomed to looking up from the worktable and resting his eyes on the arabesque design of this decidedly French gate. He came to view it as a symbol of the love and respect he had for his friends. It became the starting point for many paintings, prints, and eventually even large-scale sculptures. *The Crommelynck Gate (Chinese Pottery)* is one of a group of gate paintings that Dine created during the late summer and early fall of 1983. The form of the gate itself borders on pure abstraction, a symmetrical design of gracefully flowing curves. This two-dimensional pattern offered Dine an opportunity to push the image as close to pure abstraction as his commitment to representation would allow. Along the ground plane he lined up a sequence of Chinese vessels, each with a voluptuous shape that accentuates the lines of the gate itself.

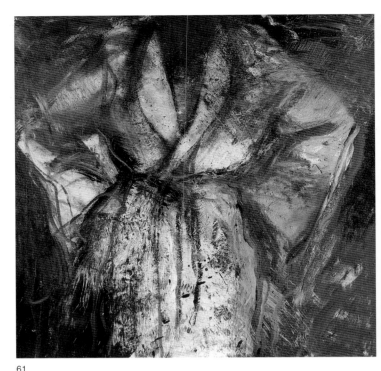

61

After Dine first returned to the United States in 1971, he created a series of large heart paintings. He then stayed away from this image for ten years, returning to it in 1981 with the same vigor he applied to his new tree and gate images. As with those new themes, as well as with the robes of the mid- and late 1970s, a single image dominates the entire canvas. The heart is no longer the small plump red element merged into a large composition that appeared in the Picabia-inspired group. Now, in pictures such as *Romancing in Late Winter,* it is an immense sensual shape that bulges out toward the edges of the large canvas. The landscape reference prevails as the soft greens of retreating winter overlap with the light browns of the dry earth. Between the curves of the heart's cleavage is a glimpse of clear blue winter sky.

The mood shifts in the ten-foot-long canvas of a heart and a half in *Painting a Fortress for the Heart.* The soft sensuality of *Romancing in Late Winter* is replaced here by a deep sorrow. The boldness of the scale, the enormousness of the one heart, and the way the second one is cut off at midsection all combine to give this sense of sorrow a profound gravity. Because the canvas just barely contains it, the size of the *Romancing* heart seems to make the "romance" explosive. By contrast, the size of the *Fortress* heart is burdensome, and the severed heart implies loss, something torn asunder, a pairing now out of balance. This painting was executed in acrylic, which the artist allowed to crust in such a way that the paint symbolically serves as a protective "fortress." The heart is vulnerable. It requires a sturdy shield.

At this point in his career Dine frequently talked about his images and their role in his art. This was an issue he was struggling with, and as he created the large tree, gate, and heart pictures he seemed to want to pull away from dealing with the image per se and to put more emphasis on the process of creating his works and the role of the paint in conveying meaning. He commented that in

61. *Desire (The Charterhouse),* 1981
Acrylic on linen, three panels: 7 x 21 ft. (2.1 x 6.4 m), overall
Private collection, New York

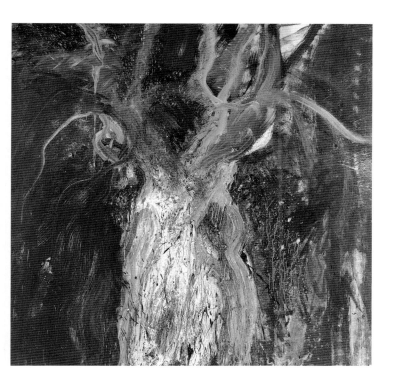

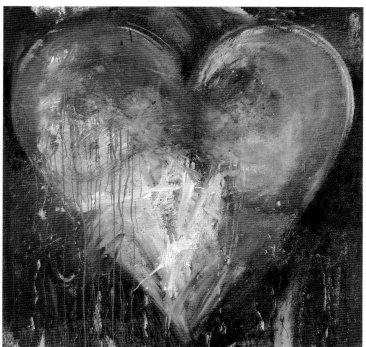

the heart pictures of the early 1980s, "I've tried to depict . . . years of joy and pain. In painting, I would not care to 'illustrate' these emotions. I would rather keep looking very hard and see if the paint itself can do the job. Actually I know it can."[34]

This interaction between the power of the image itself, particularly when it is so large that it looms out at the viewer, and the raw expressive energy communicated through the painting technique is exemplified in a huge three-panel picture, *Desire (The Charterhouse)*. This 1981 triptych, which spans twenty-one feet, is a grisaille picture of a robe, a tree, and a heart. In all three panels there is a grand gestural quality to the paint, ranging from thick, broad strokes to skinny, runny drips. A blinding light emanates from the white, just as we are drawn into the emotional blackness of the work's interior darkness. Dine clarifies the title of this painterly tour de force by stating that "this desire [of the title] is not specifically desiring someone or something; it is the state of desiring to remove the state of loneliness."[35]

All three of these images—the heart, the robe, and the tree—appear in Dine's prints of the early 1980s, both singularly and in repeats of the triptych combination just discussed. One three-part version is called *Desire in Primary Colors* because pastel shades of red, yellow, and blue serve as the background for the black drawings. Just as Dine in the fall of 1981 had indulged in a journey toward abstraction, using the familiar images in the *Charterhouse* picture to prove that "the paint itself can do the job," so a few months later in his prints did he push his technical wizardry to full tilt. The black marks used to make the images in *Desire in Primary Colors* were, amazingly enough, created without the acid traditionally used in the intaglio process. Instead, Dine worked the plates and rendered the images only with electric tools: a die-

grinder, a Dremel, and a German vibrating needle.

Dine had made woodcuts earlier in life such as *Woodcut Bathrobe*, 1975, but it was during this same fertile period of the early 1980s, when he took full command of power tools, that his interest in this inherently expressive technique intensified. Wanting to explore the tree image in all mediums, he cut from a pitted and scarred drafting tabletop the wood used 63 to make *The Big Black and White Woodcut Tree*. Dine worked the broad lines of the image into the surface with an electric chisel and the finer ones with the Dremel. What is depicted thus is the same as the material used to depict it—an apt and satisfying marriage of image and process.

A year later Dine cut twenty-nine small woodcuts to illustrate a *livre de luxe* of *The Apocalypse*. 4 Included is a woodcut self-portrait titled *The Artist as Narrator*. This self-portrait constitutes one of his most traditional applications of the woodblock technique. Yet even limiting himself to the rather simple contrast of black and white created with raw, jagged gouges, the artist achieved an excellent likeness that is in keeping with his other penetrating self-portraits.

Dine produced another distinct body of work, starting in 1983, that combined many of his concerns of the 1980s with his earlier interests. In a makeshift studio that he established in Los Angeles's Biltmore Hotel, Dine created a dozen drawings after work by Vincent van Gogh. They make evident his continued interest in working on a large scale, in exploring the potential of electric tools, and in merging his commitment to representation with his urge toward abstraction. He directly referred to art history and continued to elevate drawing as a medium in its own right.

This project was completed in a fury of activity during the winter of early 1983, but it had germinated over a much longer time. In the mid-1970s Dine and R. B. Kitaj (a fellow Ohio painter living abroad) had together seen the exhibition *Van Gogh in London* at the Victoria and Albert Museum. Dine was particularly impressed by the way van Gogh had used black and white in his drawings and by his isolation of a single image on the sheet. This exhibition was one of the catalysts that inspired Dine's figure drawings of the 1970s; almost a decade later, he found new inspiration in a book of van Gogh's drawings.

All of Dine's van Gogh drawings are on thick paper that the artist literally attacked, almost throwing his drawing materials—charcoal, ink, and enamel automobile paint—at the sheet in order to build up the images of rural workmen or trees. Then Dine tackled the preliminary drawing with a rotary grinder that had sanding disks attached; in effect, this power tool became a high-speed eraser. It left van Goghesque swirling patterns and restored the white of the paper, which in certain cases Dine allowed to remain as part of the next stage of the composition. He then drew again and erased again. This process of creating, destroying, reinventing,

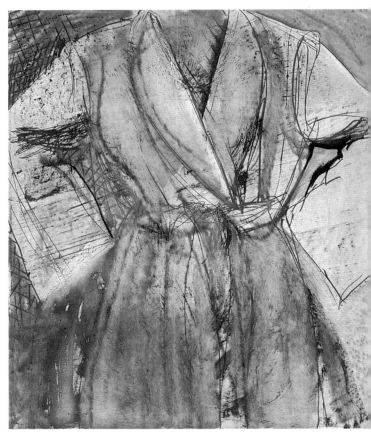

62

62. *Desire in Primary Colors*, 1982
Aquatint and electric tools, from four copper plates, paper size: left and right panels—30 x 22½ in. (76 x 57 cm); center panel—30 x 20 in. (76 x 51 cm)
Edition of 40, published by Pace Editions

63. *The Big Black and White Woodcut Tree*, 1981
Woodcut, 58½ x 42½ in. (148.6 x 108 cm)

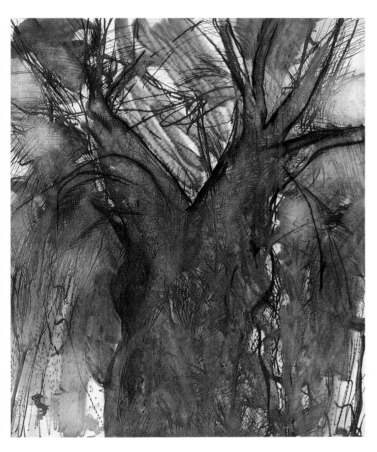

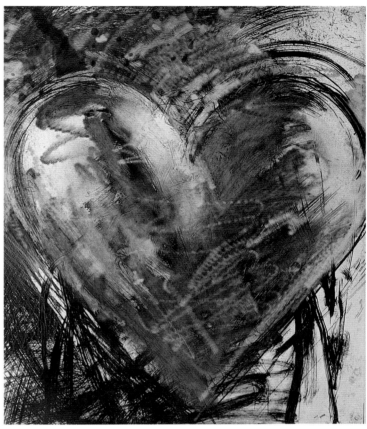

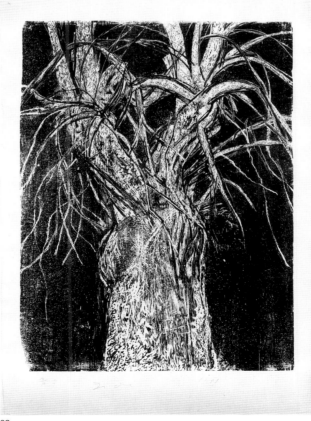

63

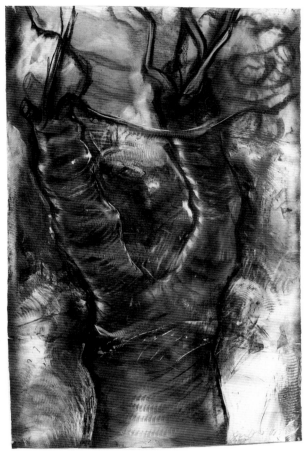

64

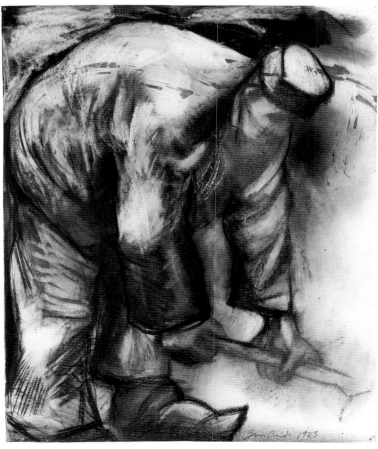

65

of erasing again and creating again, led to highly worked compositions in which layer upon layer of marks were melded with the pentimenti left behind by the grinder. Dine would stop work just seconds before the image was obliterated and the paper ripped to shreds. The laborers as they pursue their hard work retain the same poignancy and respect that van Gogh had originally given them. From a distance, the tree drawing has the same frantic, nightmarish appearance of van Gogh's original, and its larger scale makes its inherent sense of anxiety even more unnerving.

65, 66

64

64. *Drawing from Van Gogh I*, 1983
Mixed media on paper, 17¼ x 45½ in. (43.8 x 115.6 cm)
Private collection, New York

65. *Drawing from Van Gogh VII*, 1983
Mixed media on paper, 54½ x 45¼ in. (138.4 x 115 cm)
Susan R. and L. Dennis Shapiro

66. *Drawing from Van Gogh VIII*, 1983
Mixed media on paper, 65 x 45 in. (165 x 114.3 cm)
Private collection

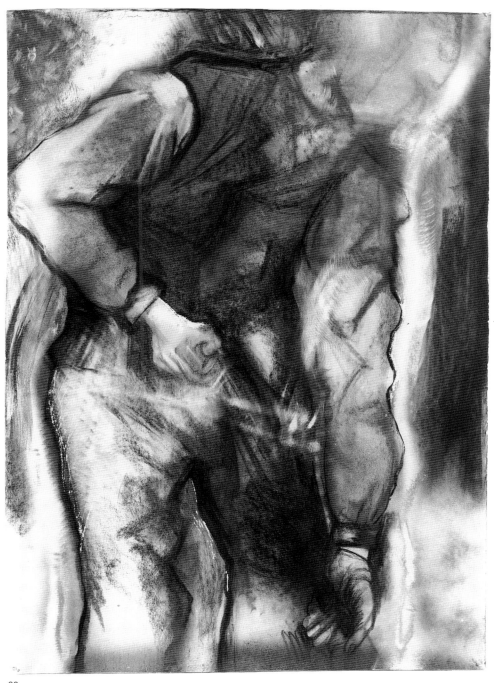

66

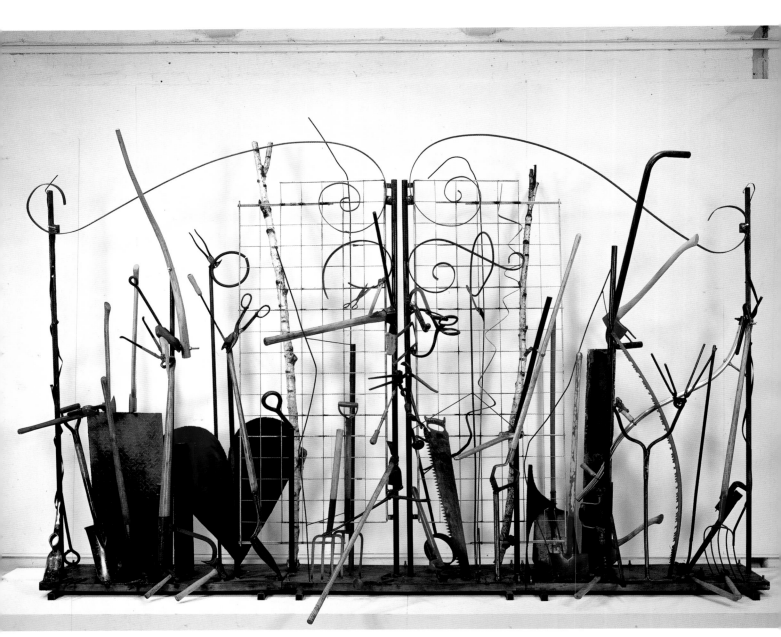

5 "Following My Passions"

When Dine first appeared on the New York art scene, he was an object maker and an environmental artist—that is, a sculptor. His 1970 retrospective at the Whitney was filled with sculptures and with paintings that had objects suspended from them. By the end of that decade, however, Dine was no longer thought of as a sculptor. The enthusiastic response to his paintings of the late 1970s and early 1980s, plus his outpouring of drawings and prints, overshadowed his early work in three dimensions. His early sculptures clearly recorded the imprint of the 1960s, but then he made no three-dimensional work that reflected the changes triggered by his first European stay, his many visits since then, his immersion in art history, and his development as a draftsman.

In the late 1970s Dine took a tentative step toward sculpture by making a few clay and plaster heads of Nancy, but not until the early 1980s did he apply his full energies to working in three dimensions—in London, Los Angeles, and Walla Walla, Washington. Within ten years he produced such a large and varied body of work that it became impossible for anyone not to think of Dine as a sculptor as well as a painter, draftsman, and printmaker.

The search for new images so evident in Dine's paintings of the early 1980s carries over to his work in three dimensions. The first two images that he approached with seriousness as sculpture were the gate and a variation on the famous Hellenistic sculpture the Venus de Milo. Each offered a three-dimensional equivalent of his favored two-dimensional compositions: the gate became a substitute for the picture plane, on which he could display his beloved objects, and the Venus became an iconic figurative form—a female robe, so to speak—that he could work and rework until it became a member of his family of images.

The first gate that Dine sculpted—*Crommelynck Gate with Tools*—began as a classroom project that he undertook with a group of students at Otis Art Institute in Los Angeles early in 1983, during the same period he was working in London on the large gate paintings. Creating this work was as much a learning process for Dine as for the students. First over sixty objects were

68

67. *The Gate, Goodbye Vermont,* 1985
Wood, steel, tools, and paint, 9 ft. 3½ in. x 14 ft.
2 in. x 5 ft. 2½ in. (2.8 x 4.3 x 1.6 m)
National Gallery of Art, Washington, D.C.

68. Jim and Nancy Dine standing in front of
The Gate, Goodbye Vermont, in progress, 1985

cast in bronze, which became his inventory, to be organized into a composition using the gate as a supporting device. A documentary photograph from the outdoor studio at Otis offers a glimpse of the artist working to solve his compositional puzzle, with the component parts laid out before him.

Two sculptures from later in the 1980s—*The Gate, Goodbye Vermont* and *Wheat Fields*—take this compositional approach to successful resolution. As Dine prepared to leave his home in Putney, he created a three-dimensional version of *Our Life Here* as tribute to his time in New England. He began with a steel framework that combined the essential arabesques of the French gate with an open-grid rack. This served as his three-dimensional canvas. Along its base he lined up saws, shovels, and pitchforks, and on the rack he displayed scissors, hammers, wrenches, and other workmen's implements associated with his many previous tool-related works of art. To these he added two birch branches and a steel plate sprayed in his familiar green and blue—both the branches and the colors being direct references to the Vermont landscape. The steel heart nestled among all these elements leaves no doubt as to Dine's affection for the landscape he is about to leave behind.

While working at Otis, Dine heard about the Walla Walla Foundry in Washington state, and one of his later pieces made there represents a northwestern version of *The Gate, Goodbye Vermont*. Walla Walla has a landscape radically different from Vermont's, but it similarly satisfied Dine's need to reside, at least part of the year, in an agricultural area where farming equipment and tools were functioning elements in everyday life. After observing the rows of farm machinery that line the road between his house in Walla Walla and the foundry, as well as the miles and miles of fertile farmland that dominates this region, Dine created *Wheat Fields*. A sixteen-foot beam connects a pair of tractor tires. This beam became the shelf on which Dine propped both familiar objects of devotion and newer subjects of investigation—including several small statues and, most prominently, an oversize skull. At first glance it seems that this is a collage of found objects, a fragment of farm machinery combined with local finds from yard sales and the like. Then one discovers that the entire work has been cast from bronze, with a combination of patina and hand painting used to color its complex surfaces.

The first time the Venus appeared in Dine's art it was one object among many in a cluttered painted composition similar to the artist's sculpted homages to Putney and Walla Walla. It was juxtaposed with a skull, a conch shell, and other elements in *My Studio No 1; The Vagaries of Painting; "These Are Sadder Pictures,"* one of the 1978 still-life paintings.[36] Four years later, he began the work that would transform the Venus into a principal theme. It is significant that Dine began to concentrate on sculpture through a found image that looms so large in the history of western sculpture: the Venus de Milo. He would modify it, rework it, and transform it, in bronze and wood, etchings, woodcuts, silkscreens, and lithographs. Through this transformative process the artist took a

69

69. Dine working on *Crommelynck Gate with Tools*, at Otis Art Institute, Los Angeles, 1983

70. *Wheat Fields*, 1989
Painted bronze with patina and pigment, 6 ft. 8 in. x 14 ft. 4 in. x 8 ft. 3 in. (2 x 4.4 x 2.5 m)
The Denver Art Museum

PAGE 78

71. *Venus in Black and Grey*, 1983
Painted bronze, 64 x 23 x 25 in. (162.6 x 58.4 x 63.5 cm)
Private collection, Sonoma County, California

72. *Study for Two Venuses*, 1983
Bronze, 21¾ x 15 x 12 in. (55 x 38 x 30.5 cm)
Private collection, Sonoma County, California

73. *A Lady and a Shovel*, 1983
Bronze, 26 x 16 x 16 in. (66 x 40.6 x 40.6 cm)
Private collection, New York

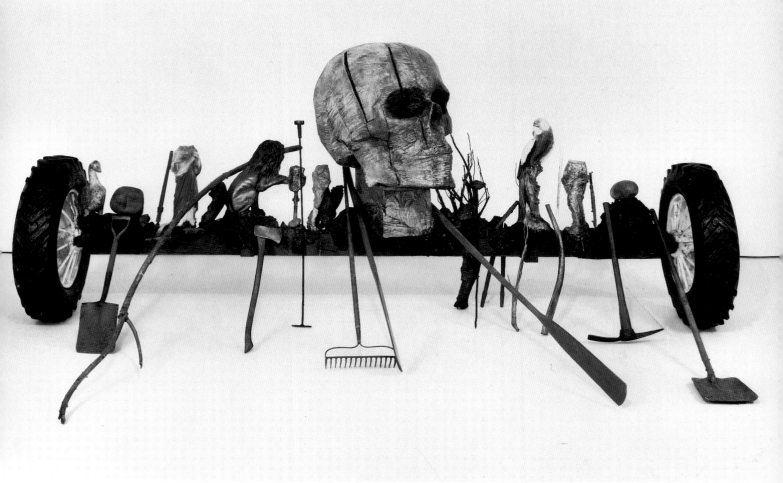

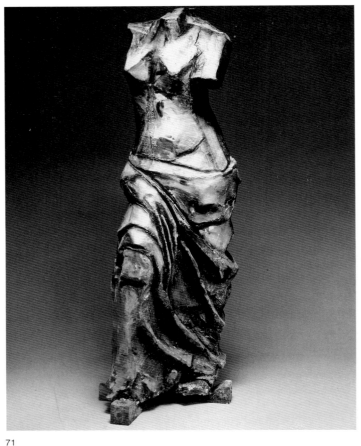

71

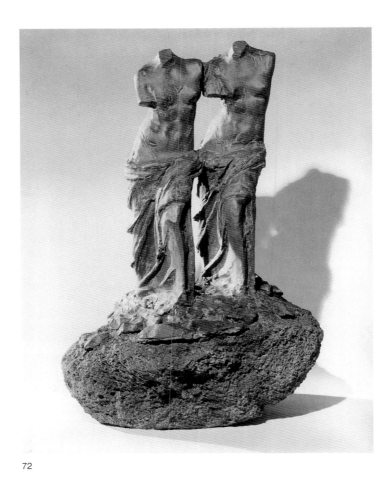

72

sculpture in the public domain and added it to his own lexicon of personal images.

71 Dine began *Venus in Black and Grey* by having a souvenir figurine of the Venus de Milo enlarged into a clay version that was crudely formed but proportionately accurate. He then went vigorously to work learning a new form. After chopping off the head, he threw more clay at it and then chopped this off. The final state is noted for its corporeality and aggressive stance. Broad shoulders and pointed cubistic breasts characterize the upper torso. The viewer's eye is guided down past the thick waist by vertical incisions that mar the bare flesh. The drapery is bulky, falling in awkward gathers over the broad hips and thighs.

 Dine also fashioned a softer, more tender version of the Venus.
72 Among the first sculptures he cast in Walla Walla were *Study for*
73 *Two Venuses* and *A Lady and a Shovel;* in both, the graceful sensuality of the original is enhanced rather than denied. In *Study* the elegant curves are emphasized by a literal doubling; in *Lady* the shovel suggests a protective niche.

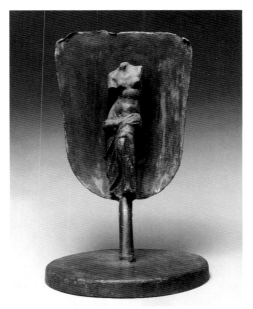

73

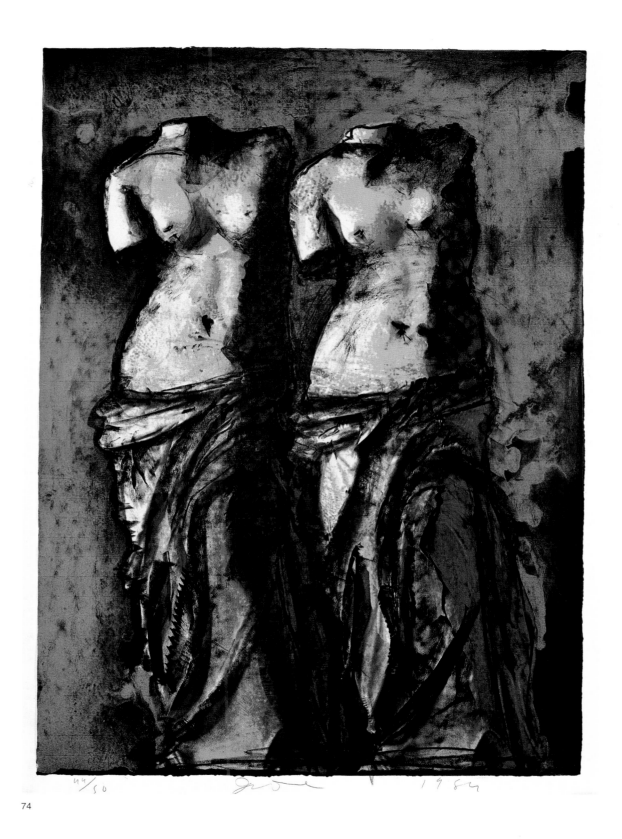

44/50 1984

74

74. *Double Venus in the Sky at Night,* 1984
Lithograph and silkscreen, 41½ x 30¼ in.
(105.4 x 76.8 cm)
Edition of 50, published by Pace Editions

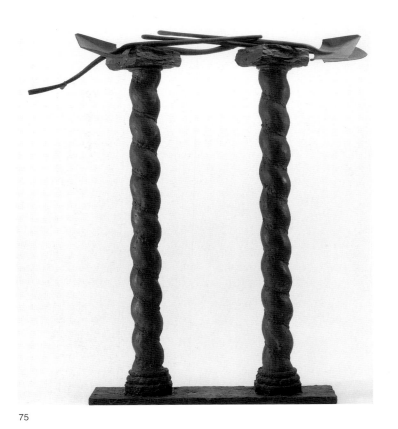

75

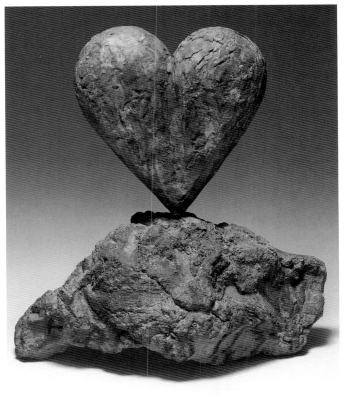

76

After Dine ventured into sculpture with his gates and Venuses and after he became comfortable working in Walla Walla, he could not resist the temptation to reinterpret his older forms in this new medium of bronze. He was lured back as far as the *Hammer Doorway,* which reappeared as *The Arch:* two twisting columns topped by a lintel of overlapping shovels. A sculpted bronze heart recalls this image's first appearance as a large stuffed prop in *A Midsummer Night's Dream.* Now it is precariously balanced on a lumpy rock, restored to three dimensions again after years of two-dimensionality. But even now Dine was unable to give his male icon any significant physical substance: he carved a robe only in relief— *Walla Walla Robe.*

The nonstop pace of Dine's printmaking was particularly noteworthy during the early 1980s, when he explored these newest sculptural images in printed form. The Venus dominated as he tackled a two-dimensional version of his sculptural obsession in work after work. Just as the sculpted Venus took on different guises, so did the printed one. The sensuality of the double Venus is translated into one of the artist's few combined silkscreen-lithographic prints, *Double Venus in the Sky at Night.* To begin, Dine created a silkscreen in eight tones of gray, brown, and black. Over this he laid two lithographic printings: a tonal black drawing and a background wash of blue-green. Now these headless female beauties pose gracefully against the softness of a twilight sky.

75. *The Arch,* 1983
Cast bronze, 97 x 86 x 30½ in. (246 x 218 x 77.5 cm)
Private collection, Sonoma County, California

76. *Heart on a Rock,* 1983
Bronze, 18½ x 16¼ x 10 in. (47 x 41.3 x 25.4 cm)
Private collection, Sonoma County, California

77. *Walla Walla Robe,* 1984
Painted bronze, 48 x 36 x 2 in. (122 x 91.4 x 5 cm)
Private collection

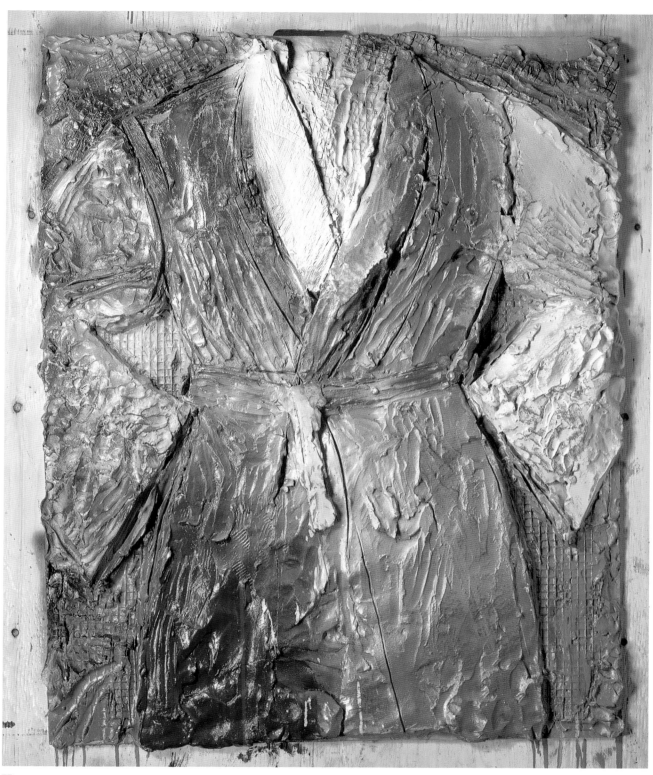

77

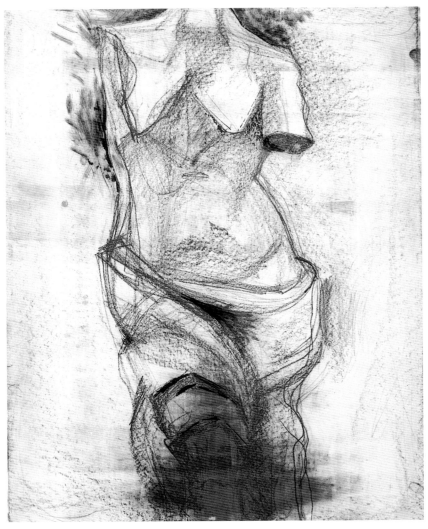

78

The sculpture *Venus in Black and Grey* also has many printed
78 counterparts. *The French Watercolor Venus* began as a soft-ground
drawing based on the sculpture. After this drawing was deeply bit-
ten with acid, providing clear lines of contour, Dine heightened it
with the Dremel and an electric drill with a grinding wheel and a
wire-brush attachment. Finally, the soft-ground drawing with elec-
tric tool accents was covered with a rainbow wash of colors. Other
80 etchings from this period, such as *Lost Shells* and *The Side View,*
emphasize how Dine's masterful drawing with acid and electric
tools, often highlighted with hand-coloring, was intended to
communicate in two dimensions the sculptural quality of the
original.

Dine's desire to make prints the size of paintings or even the size
81 of his sculptures is apparent in his grand-scale effort *Youth and the*

78. *The French Watercolor Venus*, 1985
Hand-colored soft-ground etching, 41⅝ x 31¾
in. (105.7 x 80.6 cm)
Edition of 16, published by Pace Editions

79. *Lost Shells*, 1985
Hand-colored soft-ground etching and drypoint,
30¼ x 44 in. (77 x 112 cm)
Edition of 50, published by Pace Editions

80. *The Side View*, 1986
Etching, soft-ground etching, and drypoint, 43¾
x 43 in. (111 x 109 cm)
Edition of 20, published by Pace Editions

79

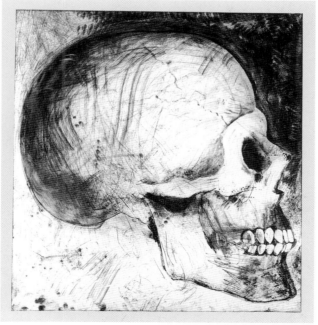

80

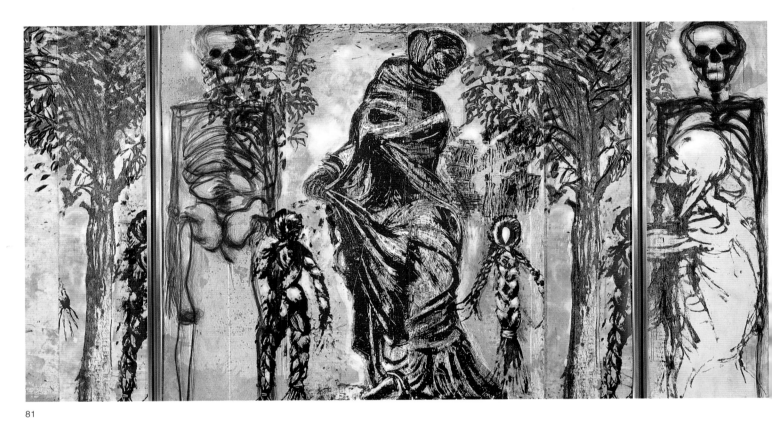

81

81. *Youth and the Maiden,* 1987–88
Triptych printed in woodcut, heliorelief woodcut,
soft-ground etching, spit-bite etching, and dry-
point, with hand-painting in acrylic, three pan-
els: 78⅜ x 91⅞ in. (198.9 x 233.4 cm), overall

82. *Three Red Dancers,* 1989
Charcoal, oilstick, and watercolor on paper,
three sheets: 62 x 117¼ in. (157.5 x 297.4 cm),
overall
Mr. and Mrs. Robert Lifton

82

Maiden, produced at Graphicstudio in Tampa, Florida, during 1987–88. This three-panel work resembles an altarpiece, with a dominating central section flanked by side panels. The midsection features a six-foot graphic rendering of a small Hellenistic statue of a dancer, which Dine knew from the Metropolitan Museum of Art. The formal relationship to the Venus is obvious, but this female figure is fully draped in swirling layers of fabric. To the figure's left and right are dolls made of braids—traditional wedding tokens, symbols of fertility, that call to mind Dine's earlier use of hair as a sexual reference. A tree—full of leaves rather than barren like the Vermont apple—and a skeleton with black hollow eyes are repeated in all three panels and clearly symbolize the juxtaposition of life in its fecundity with death in its finality. In addition to this rich iconography, *Youth and the Maïden* offers the visual delight of a plethora of printed marks produced by an extraordinary mixture of technical processes.

Once Dine took up drawing in earnest during the mid-1970s, he never stopped. The challenges of draftsmanship that he took on have complemented his other activities ever since. It is no surprise that as Dine embarked on his almost new career as a sculptor, his enthusiastic study of great classical sculpture yielded a large body of drawings. The Hellenistic figure that served as the central element in *Youth and the Maiden* was also a subject that Dine drew repeatedly, working from a series of photographs in a Metropolitan Museum publication that captured the dancing maiden from several angles. His three versions in *Three Red Dancers* dramatize 82 the suggestive nature of the figure's seductive movements by placing her against a dazzling red background. The whirling motions are brought to life by thick diagonals of charcoal and oilstick.

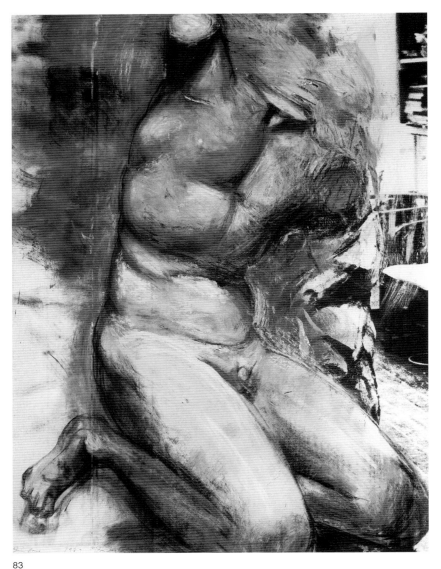

83

Two other drawings from antiquities—*Twisted Torso of a Youth*
and *Boy with a Goose*—are from a series that the artist titled *In
der Glyptothek*. These examples date from 1989, but he made
drawings of sculptures in the Glyptothek, a museum in Munich,
from 1987 through 1992; the idea for the project had originated
with his first visit there, in 1984. By the early 1980s Dine felt as
much at home, if not more so, in Europe as in the United States,
spending a good part of the year working and living in different
cities. In 1984 he set out to visit Munich, the destination of so
many nineteenth-century artists from his hometown of Cincinnati.
It was no coincidence that Dine, like his predecessors Frank Duve-
neck and John Henry Twachtman, would now work in this Ger-
man city and take back to America the knowledge he acquired
there of the ancient arts.

Dine approached this process of drawing from the originals—
which he did in the early morning hours, before the museum
opened to the public—as a method of learning about sculpted

83. *Twisted Torso of a Youth* (*Drawing of a
Work by Ilioneus, c. 300 B.C.*), 1989
Oil stick, acrylic, charcoal, and watercolor over
screenprinted photograph on two sheets of
paper, 58 x 44¼ in. (147 x 112.4 cm), overall
Private collection, New York

84. *Boy with a Goose* (*Roman Copy after a
Work in Bronze*), 1989
Charcoal, watercolor, chalk, and conté crayon
on paper, 47¾ x 41⅞ in. (121.3 x 106.4 cm)
Glyptothek, Munich

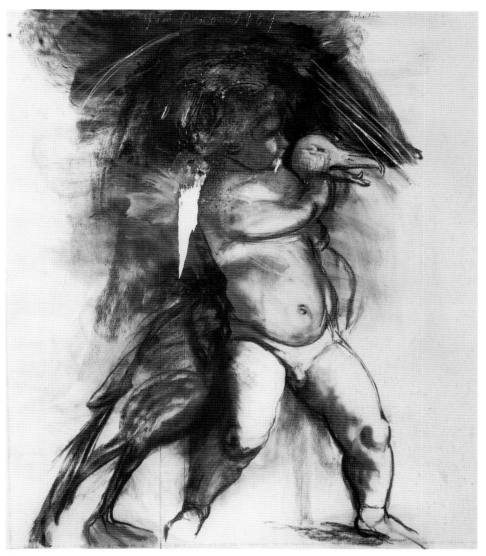

84

form. He did not draw the boy grappling with the goose or the kneeling youth as if they were stone; these are not academic studies of stone sculptures. Rather than recording them as ancient carvings, through his graphic transformation Dine willed them back to their original state of living beings. Like the van Gogh drawings that came earlier, these are impatient and heavily worked. The urgency of the line, the exaggerated tonal variations, the large scale, and the obvious link to the great monuments in Western art history result in an expressive power that hits the viewer with full force.

When Dine turned fifty, in 1985, he made the decision to give himself the gift of reentering psychotherapy. This was his third period of analysis, the first having been from 1962 to 1964 and the second for several years during the mid-1970s. Dine speaks very positively of his analytical work of this third period, crediting it, in part, with giving him the courage to use whatever images (some from dreams) offered the most direct means of expression. He no

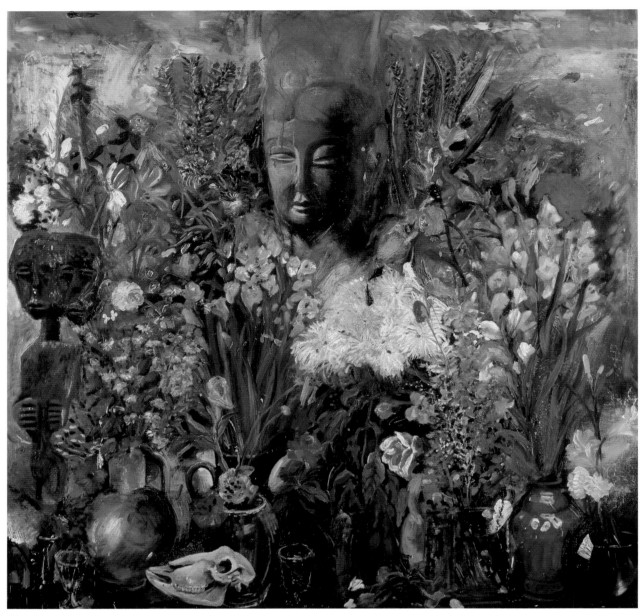

85

longer felt the need to self-edit his feelings.

In a group of paintings from the late 1980s the artist allowed himself to create pictures loaded with images. These are complex compositions that offer a tremendous amount of symbolic information. The possible interpretations are open-ended, but the emotional resonance is unquestionable. In talking about the specific meaning of the images and how these images are joined together in each picture, the artist stated, "A painting for me is like a receptacle that holds a lot of things that aren't necessarily logical."[37]

Dine refuses to be pinned down about the meaning and allusions of the multitude of things in, for example, *Boxer in Eden (Voodoo)* and *The Anchoress,* but he does offer clues through his titles. A friend of the artist, Mark Boxer was a celebrated English journalist and cartoonist, who had recently died. This picture is a tribute

85

86

85. *Boxer in Eden (Voodoo),* 1988
Oil on canvas, 72 x 78 in. (183 x 198 cm)
Private collection

86. *The Anchoress,* 1988
Oil on canvas, 120 x 132 in. (305 x 335 cm)
Private collection

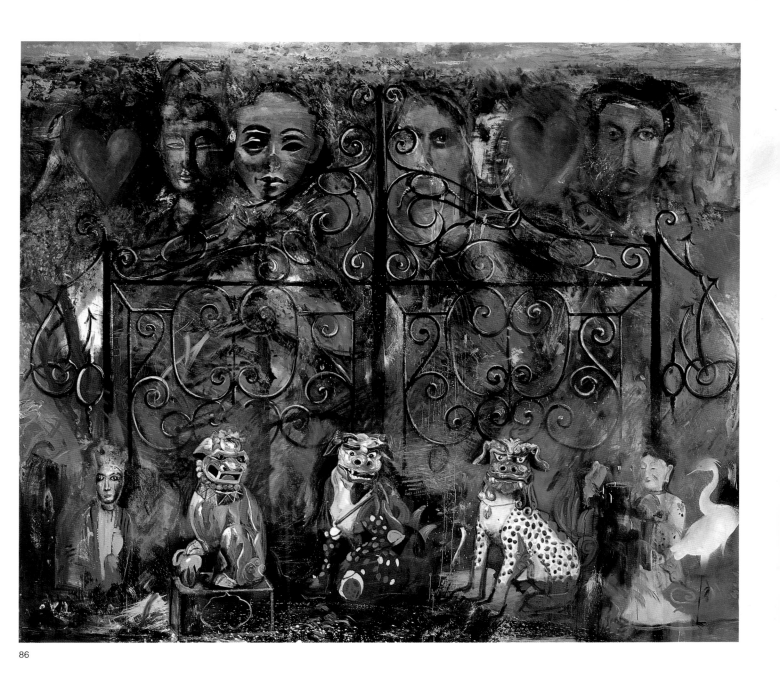

86

to him, a commemorative offering but not a bleak or mournful testament; rather, it teems with the bounty of life. The only blatant reference to death is the animal skull in the lower left corner. Flowers can, of course, imply the brevity of life, but here they are painted as a crowded plenitude that symbolizes the pleasures and beauty of worldly existence. The serene head of the bodhisattva that peers through the foliage suggests the possibility of spiritual fulfillment.

The Anchoress is a reference to Saint Julian of Norwich, a fourteenth-century mystic and woman of the church. Her faith in her own visions inspired Dine to trust his own. Through the ironwork of the Crommelynck gate peer the staring eyes of both Eastern and Western icons of art history. Lined up in front of the gate are its guardians. All float in the familiar shallow, ambiguous space that

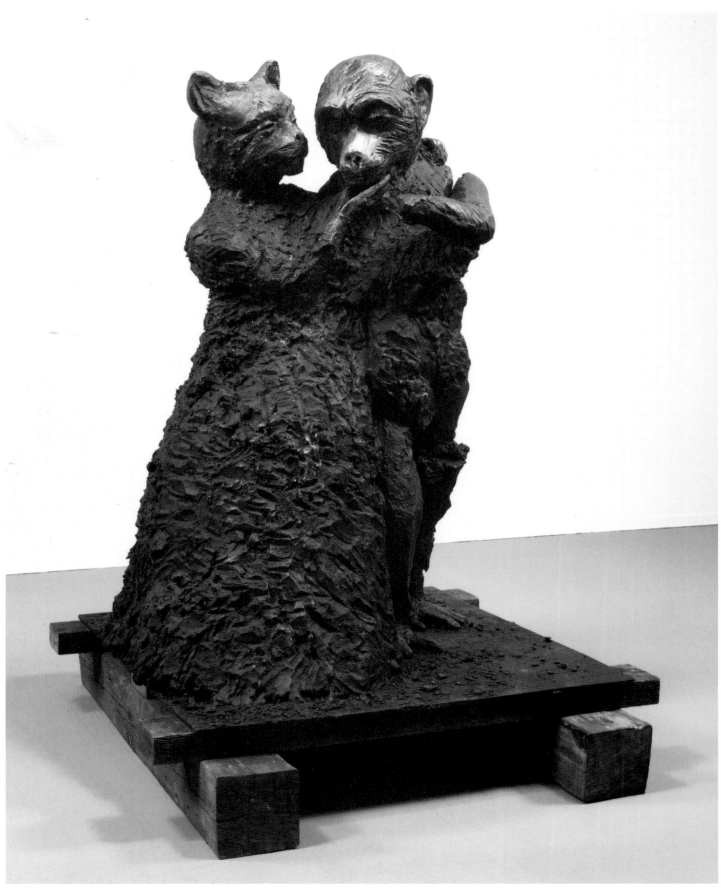

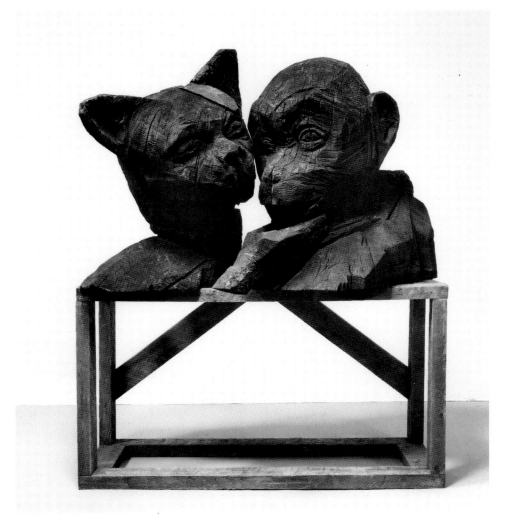

88

87. *Ape and Cat (At the Dance)*, 1993
Bronze and wood, 79 x 54¼ x 60 in. (200.7 x
137.8 x 152.4 cm)
Private collection, New York

88. *Ape and Cat (Pitch Black)*, 1992
Charred wood and wood, 92 x 73½ x 49½ in.
(233.7 x 186.7 x 125.7 cm), overall
Private collection, New York

characterizes most of Dine's paintings. In one picture, we move
from a landscape of angry flames to the serenity of calm, blue
skies.

According to conventional biographical measures Dine's "mid-
career" began with his return from Europe in 1971, his early work
having been summarized in the Whitney retrospective of the prior
year. His mid-career could be seen as extending until the end of the
1980s, with the Walker Art Center's *Five Themes* exhibition of
1984 and the several print and drawing exhibitions of the period
offering partial summaries. But Dine, at the age of sixty, is by no
means ready to slip into anything resembling a late-career frame of
mind. During the 1990s he continues to work at a frantic pace,
attacking all mediums with unbounded energy and drive and con-
tinuing his search for new images, such as the ape and the cat. 87, 88

The artist continues his own honest recording of the passage of
time through his ongoing portraits of himself and his wife. Both of

89

90

them appear in a revealing pair of drawings from 1989: *Nancy in June* and *Self-Portrait*. Time has softened their gazes. Gone are the harsh glares and angry expressions of earlier portraits. In each drawing the collars mark the separation between the detailed rendering of the facial features and the artist's penchant for having the image suddenly drop off into the whiteness of the sheet.

Dine's fluctuation between the specificity of his draftsmanship and the open-endedness of his symbolism has continued in the 1990s, and it is interesting to juxtapose his portrait drawings with the large diptych *Venus and Neptune I*. There are no heads in the latter and thus no facial features—i.e., no specific identities. But something left out of the portraits is evident here: Dine's archetypal male and female forms, his essence of masculinity and femininity. The goddess of love and the god of the sea: his Venus and his robe, the bare-breasted representation of female sexuality and the broadshouldered, fully clothed male, arms akimbo. They are not really linked. They are not embracing. But somehow they are simultaneously together and apart as they emerge from the darkness into light.

89. *Nancy in June*, 1989
Watercolor, pencil, pastel, and charcoal on paper, 28¼ x 21¼ in. (71.8 x 54 cm)
Private collection, New York

90. *Self-Portrait*, 1989
Watercolor, pencil, and pastel on paper, 30½ x 22 in. (77.5 x 56 cm)
Private collection, New York

91. *Venus and Neptune I*, 1990
Oil on canvas, two panels: 78¾ x 115 in. (200 x 292 cm), overall
Nancy Dine

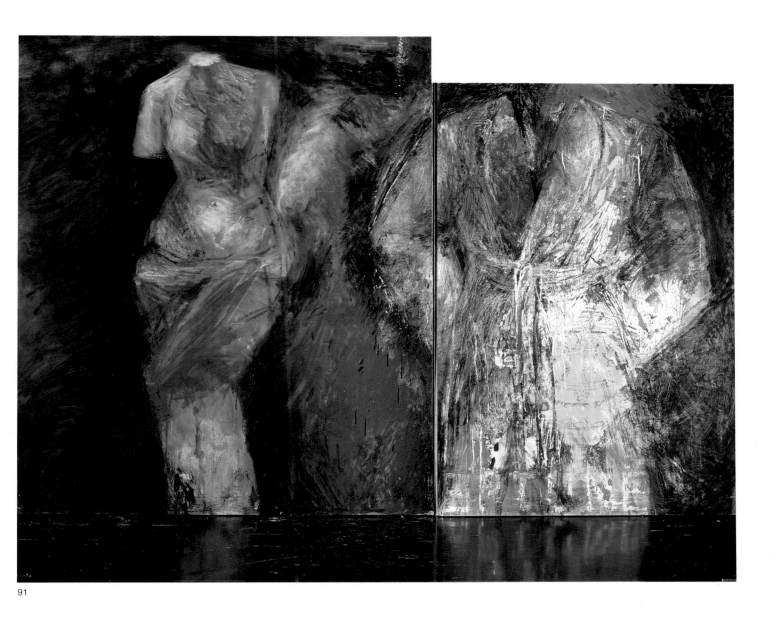

91

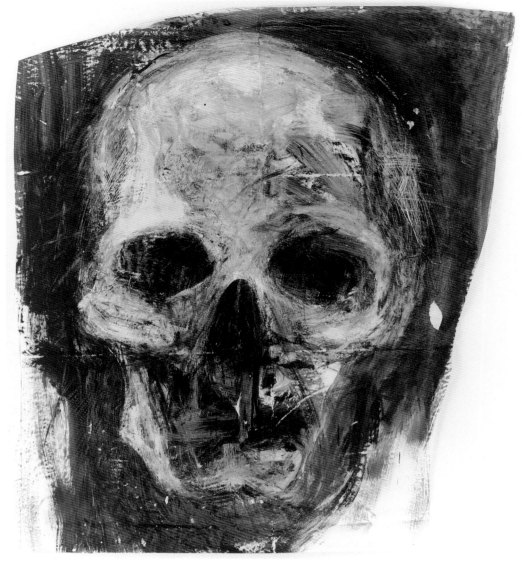

92

93

Such connecting of images, not with a narrative but with an evocative association that gives each image greater resonance, is at the core of the four-panel painting *The Sound of Your Cold Voice*. 96 From left to right appear a skeleton, a striding youthful figure, a nude female whose head is obliterated by a heart, and a man whose facial features suggest the artist's. Each figure is seen against Dine's familiar skies—some with stars and moons, others punctuated by the gnarled branches of the leafless trees. It is through the juxtapositions that the overall picture takes on added resonance, for the viewer inevitably reads the images in relationship to one another.

While his portraits and his paintings point to Dine's ongoing preoccupation with both realistic renderings and expressive symbolism, the moods captured in his art continue to fluctuate dramatically. It would be a mistake to interpret his often bleak vision as a later-life manifestation or his joyous sensuality as an expression made only during periods of particular elation. A chronological sweep of the artist's work reveals that there has always been a range in the types of feelings he has conveyed during any given period. A comparison between a 1991 skull painting on paper, 92 *October Head*, and a drawing from the Car Crash series more than 93 thirty years earlier illustrates this point, as does the juxtaposition of heart prints from two periods. On the ten-by-twelve-inch piece of paper used for the crash drawing, Dine scrawled the devastated face of an accident victim. Her eyes are black smudges, her forehead wrapped in bandages. The skull of the 1990s is many times larger than life. Once again, we are riveted by the hollows where the eyes once were and the expanse of the forehead that is raw bone.

In contrast, a recent woodcut, *The Summer*, has as much joy and 94 is as life-affirming as one of the artist's most popular etchings of ten years earlier, *The Heart Called Paris Spring*. In each there is a 95 vibrant energy that comes not only from the intense colors but also from the perfect marriage of technical skill with emotional intent. The hurried parallel lines that define the patchwork of etched color truly sing out with the pleasure of a Paris spring. Ten years later the woodcut heart in the center panel of this printed triptych sings even more loudly and with greater intensity.

The titles of these last two prints offer an apt closing metaphor for this exposition of Jim Dine's art to date. Dine has already moved through many stages of his life, from the early development and blossoming of spring to the full-blown exuberance of summer. His energy is unabated and his commitment to a "life in art" unwavering. His devotion to the expressive power of the ordinary—transformed—continues.

92. *October Head,* 1991
Charcoal, enamel, gouache, shellac, and pencil on paper, 73½ x 65½ in. (186.7 x 166.4 cm), irregular
Cincinnati Art Museum; Gift of the artist

93. *Car Crash: Band Aid, Possible Mask for Girl as a Man,* 1960
Collage, pencil, brush, wash, and red and black ink, 10 x 12¼ in. (25.4 x 31 cm)
The Museum of Modern Art, New York; Gift of the artist

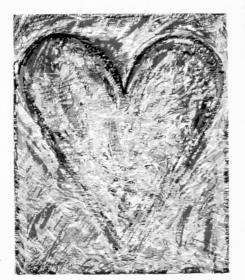

94

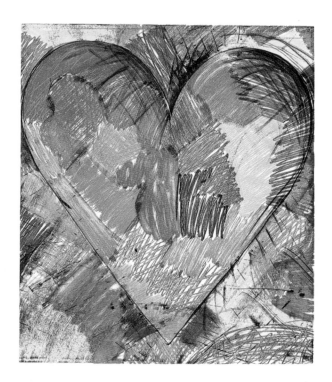

94. *The Summer*, 1991–92
Woodcut, three sheets: 45⅝ x 36 in. (116 x
91.4 cm), each
Edition of 3, published by Pace Editions

95. *The Heart Called Paris Spring*, 1982
Etching, 35⅞ x 25 in. (91 x 63.5 cm)

95

NOTES

1. Much of my information about Dine has come from our many conversations and my visits to his studios since 1984.

2. Jim and Nancy Dine's first son, Jeremiah (known as Jeremy), was born in 1959, their second son, Matthew, in 1961, and their third son, Nicholas, in 1965.

3. From a talk by Dine at the 92d Street YMHA, New York, on November 12, 1985, reprinted in the exhibition catalog *Jim Dine: Paintings, Drawings, Sculpture* (New York: Pace Gallery, 1986).

4. For excellent descriptions of Dine's performance years, see Barbara Haskell, *Blam! The Explosion of Pop, Minimalist and Performance, 1958–1964* (New York: Whitney Museum of American Art; W. W. Norton and Company, 1984), and Joseph Ruzicka, "Jim Dine and Performance," in *American Art of the 1960s* (New York: Museum of Modern Art, 1991), pp. 96–121.

5. During the summers of 1958 and 1959 Dine borrowed an uncle's cabin in Kentucky, where he made dozens of face paintings and drawings. *Untitled (Head)* (plate 6) is signed on the back "Dry Ridge Kty." There is a direct relationship between the face in the Kentucky picture, the peering eyes in *Shoes Walking on My Brain* (plate 14), and the two cutout faces wedged among the springs of *Bedspring* (plate 8). It is possible that *Bedspring* was part of *The House*, but Dine is not absolutely certain that it was.

6. Alan R. Solomon, "Jim Dine and the Psychology of the New Art," *Art International* 8 (October 1964): 52.

7. John Russell, "Jim Dine," in Russell, Tony Towle, and Wieland Schmied, *Jim Dine: Complete Graphics* (Berlin: Galerie Mikro, 1970), n.p. Russell ended his discussion of Dine's *Car Crash* by noting, "The year, once again, is 1960: five years before Warhol made his majestic altar-pieces on the same subject."

8. Confusion has arisen regarding Martha Jackson's *New Media—New Forms I and II* shows because the single exhibition catalog cover is printed incorrectly with the title *New Forms—New Media I*. Dine was included along with seventy other artists in the first exhibition, which took place June 4–24, 1960, and with seventy-one other artists in the second exhibition, September 28–October 22, 1960.

9. Harold Rosenberg, "The Game of Illusion: Pop and Gag," reprinted in Rosenberg, *The Anxious Object* (New York: New American Library, 1964), p. 58.

10. David Bourdon, *Andy Warhol* (New York: Harry N. Abrams, 1989), p. 134.

11. Ibid., pp. 137–38.

12. Dine, in G. R. Swensen, "What Is Pop Art? Part I," *Artnews* 62 (November 1963): 25.

13. Dine, in Constance W. Glenn, *Jim Dine Drawings* (New York: Harry N. Abrams, 1985), pp. 13, 15.

14. Dine, "Prints: Another Thing," *Artist's Proof* 6 (1966): 100–101.

15. Dine started using the palette image in 1963.

16. The found object attached to the canvas is a creel, a basket that fishermen use to carry their fresh catch. The artist ordered the creel from an L. L. Bean catalog, hence the title.

17. The production opened in March 1966 in San Francisco. It was also presented at the Pittsburgh Playhouse and in New York's Theater de Lys. The drawings were shown in 1968 at the Museum of Modern Art, New York; a catalog by Virginia Allen accompanied that exhibition.

18. Dine was able to make from the costume drawings four portfolios, each in a different format, which were published in 1968 by Petersburg Press, London.

19. This heart design became well known when it was published as a single motif, without the costume, on its own sheet of paper as *Red Design for Satin Heart* in the Petersburg portfolio. It was also the sole image on the poster announcing the portfolio.

20. This installation is described in William Lipke's article "Nancy and I at Ithaca—Jim Dine's Cornell Project," *Studio International* 174 (October 1967): 142–45.

21. In 1977 Dine created a limited edition portfolio, *Mabel*, that included a prose piece by Robert Creeley and twelve etchings by Dine. It was printed at Atelier Aldo Crommelynck. Dine began working with Arion Press, San Francisco, in the early 1980s. His publications with them include *The Apocalypse: The Revelation of Saint John the Divine* (1982), *The Temple of Flora* (1984), and *The Case of the Wolf-Man* (1993).

22. The word *acknowledged* is important here, for many artists of our time are working from art history but still find it difficult to admit this. They force critics and writers to speculate ad infinitum as to their sources rather than stating them up front.

23. Dine, in Graham W. J. Beal et al., *Jim Dine: Five Themes* (New York: Abbeville Press; Minneapolis: Walker Art Center, 1984), p. 96.

24. Dine, in Glenn, *Jim Dine Drawings*, pp. 36–37.

25. Beal, *Jim Dine: Five Themes*, p. 22.

26. Although all these drawings are associated with Dine's experience of concentrated working from the model that began in Vermont, not all of his drawings from 1974–79 were done *in* Vermont. For information on the categories of drawings and where they were shown, see Constance W. Glenn's two informative publications: *Jim Dine: Figure Drawings, 1975–1979* (Long Beach: Art Museum and Galleries, California State University; New York: Harper and Row, 1979) and *Jim Dine Drawings*.

27. See Thomas Krens, ed., *Jim Dine Prints: 1970–1977* (New York: Harper and Row; Williamstown, Mass.: Williams College, 1977) for the following examples: *Self-Portraits*, plates 47–55; *Self-Portrait Heads*, plates 159–61; *Self-Portraits in a Ski Hat*, plates 176–79; *Self-Portraits in a Flat Cap*, plates 180–83; and *Dartmouth Self-Portraits*, plates 184–92.

28. See Glenn's *Jim Dine Drawings*, plate 18, p. 56, for a 1958 drawing of Nancy Dine.

29. See Krens, *Jim Dine Prints: 1970–1977*, plates 162–65.

30. For a discussion of this series consult Ellen G. D'Oench's essay and the catalog entries in D'Oench and Jean E. Feinberg, *Jim Dine Prints, 1977–1985* (New York: Harper and Row; Middletown, Conn.: Wesleyan University, 1986), and Clifford Ackley, *Nancy Outside in July: Etchings by Jim Dine* (West Islip, N.Y.: ULAE, 1983).

31. Dine, in Beal, *Jim Dine: Five Themes*, p. 80.

32. Robert Hughes, "Self-Portraits in Empty Robes," *Time*, February 14, 1977, p. 65.

33. Dine, in Beal et al., *Jim Dine: Five Themes*, p. 120.

34. Dine, in *Jim Dine: Recent Work* (New York: Pace Gallery, 1981), n.p.

35. Ibid., p. 86.

36. For complete documentation of Dine's Venus imagery up to 1986, see my essay "Not Marble: Jim Dine Transforms the Venus," in D'Oench and Feinberg, *Jim Dine Prints, 1977–1985*.

37. Dine, in Marco Livingstone, ed., *Jim Dine* (Osaka, Japan: Art Life, Ltd.; National Museum of Art, 1990), p. 118.

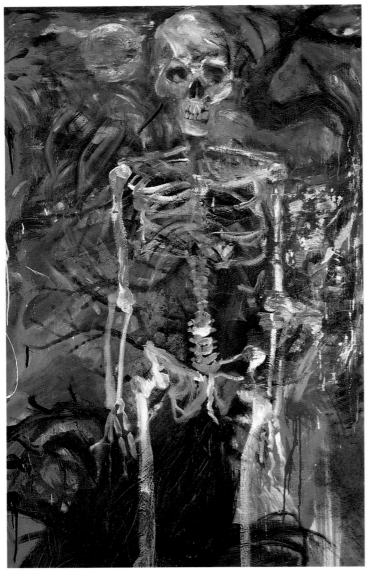

96

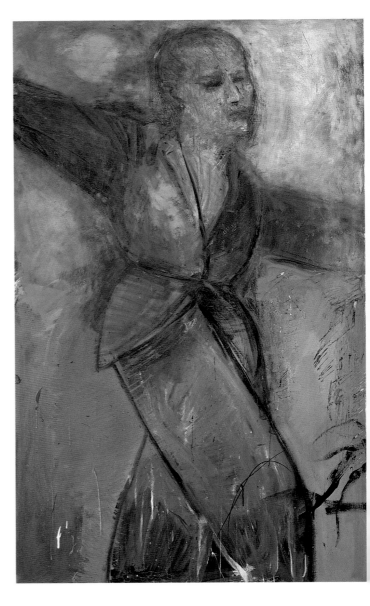

96. *The Sound of Your Cold Voice,* 1991
Oil on canvas, four panels: 64 x 38 in. (162.6 x 96.5 cm), each
Cincinnati Art Museum; Museum Purchase through The Edwin and Virginia Irwin Memorial Fund and Bequest of Mr. and Mrs. Walter J. Wichgar

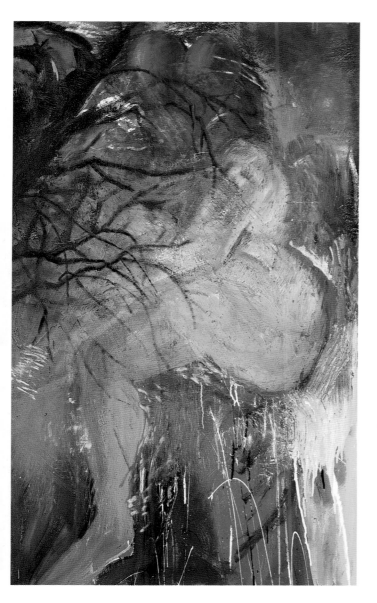

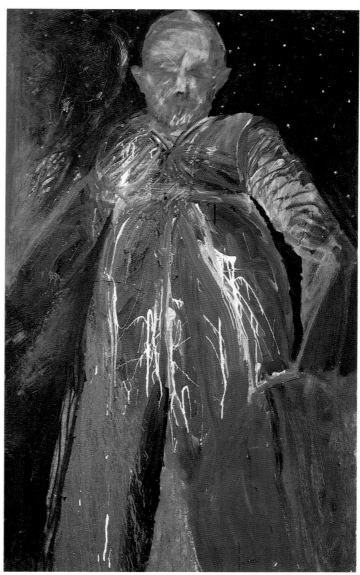

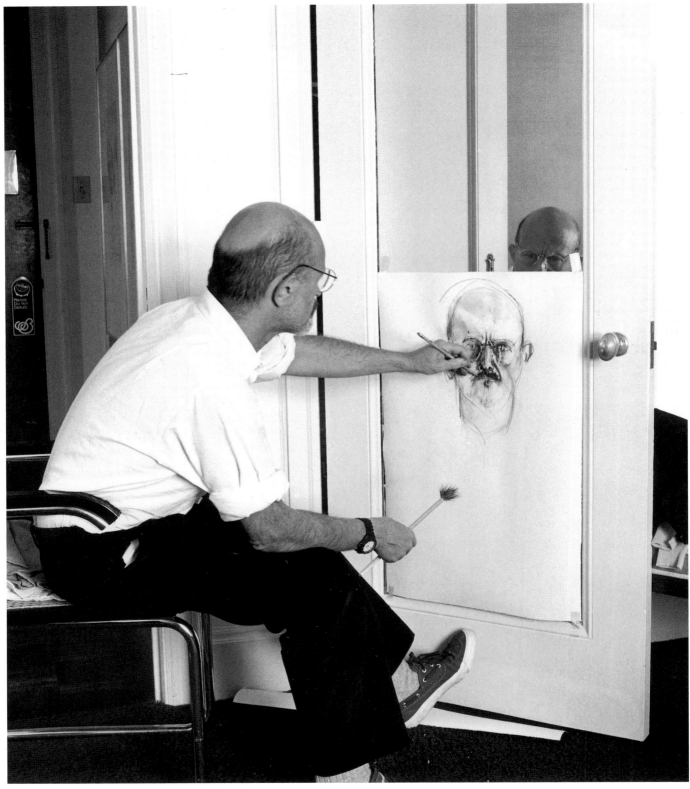

97

Artist's Statements

From the time I was very small I found the display of tools in [my grandfather's] store very satisfying. It wasn't or isn't the craftsmanship that interests me, but the juxtaposition of tools to ground or air or the way a piece of galvanized pipe rolls down a flight of gray enamel steps. My father also had a store. He sold paint (house) and tools and plumbing supplies. From the age of nine till I was eighteen I worked in these stores. I was completely bored by the idea of selling but in my boredom I found that daydreaming amongst objects of affection was very nice. I still think that white glaze on a bathroom sink or toilet is very moving. Commercial paint color charts were real jewel lists for me too.

> Quoted in John Gordon, *Jim Dine* (New York: Praeger Publishers; Whitney Museum of American Art, 1970), n.p.

I could make a hundred drawings for each one I get. I am positive that by rubbing out and trying to do better, and knowing that I can do better, the whole drawing gains a kind of history and substance that it didn't have before. . . . Overlay and rubbing out come not so much from frustration at what I'm getting as from the confidence that I can do it again and because of that specific exercise, I know I am going to get something richer than had I left it alone.

> Quoted in Constance W. Glenn, *Jim Dine: Figure Drawings, 1975–1979* (Long Beach: Art Museum and Galleries, California State University; New York: Harper and Row, 1979), p. 13.

I consider myself not a realist, but a romantic artist. . . . I consider my natural inclination toward Expressionism a great virtue.

> Ibid., p. 14.

There's no difference between shower heads and axes and hammers; they're all metaphorical, obvious stand-ins for human things.

> Quoted in Graham W. J. Beal, *Jim Dine: Five Themes* (New York: Abbeville Press; Minneapolis: Walker Art Center, 1984), p. 52.

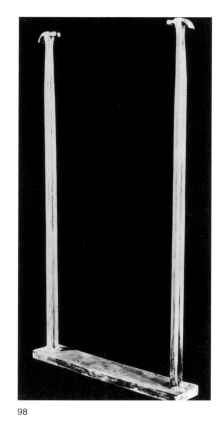

98

97. Dine drawing a self-portrait

98. *Hammer Doorway*, 1965
Cast aluminum (unique), 78 x 40½ x 7¼ in.
(198 x 103 x 18.4 cm)
Private collection, Sonoma County, California

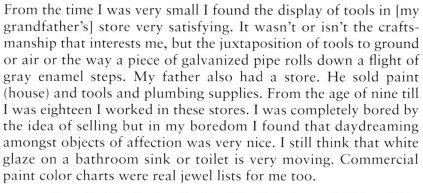

99

99. *Romancing in Late Winter*, 1981
Acrylic on canvas, 96 x 107½ in. (244 x 273 cm)
Private Collection

The hearts were a prime object. Yes, the shape! It means a lot of things. It doesn't just mean love, it's anatomical, it's all kinds of things. It refers to all kinds of anatomy, too. But it also was a way for me to hang painting onto something.

Quoted in David Shapiro, *Jim Dine: Painting What One Is* (New York: Harry N. Abrams, 1981), p. 204.

To get the frontality and sharp contours I like in my tool drawings, I place the object against the paper and run a pencil around it. Then I place it across the room and draw from it. This way I set the stage for a rigid, formalist picture. The tracing doesn't say anything so you still have to lie by draftsmanship, which pleases me no end. It lets me meander in and around the shape of the object in an atmospheric way, a romantic way, a black way. It forces me to invent.

Ibid., p. 66.

My color is always subjective. It has only been descriptive a few times, in the still lifes of the 1970s. I never really think about painting atmosphere, but what I do think about is sharpening my draftsmanship and about the power of objects.

Ibid., p. 112.

Drawing from the figure [in the mid-1970s] was making me very insecure about the earlier work, so that I felt some need to refute it in some way, which I don't now. But that experience of drawing from life has affected everything I do now.

Quoted in Marco Livingstone, *Rise Up, Solitude! Prints 1985–86* (New York: Pace Prints, 1986), p. 16.

I think the biggest inaccuracies that have been written about me have to do with Pop art and my relationship to it. There's been no real understanding of my strange voyage in art. . . . My work had such a homemade look about it next to all these manufactured images. I have always felt closer to those Europeans like Giacometti, Morandi, Balthus, Magritte—not stylistically, but those were careers that I thought were exemplary in art. In America it has always been about schools, like some rousing boys' club or fraternity that I simply didn't want to be involved with.

Ibid., pp. 18, 20.

Drawing is the way I speak the best, the clearest. Essentially I'm a draftsman.

Quoted in "Jim Dine at 40," *Print Collector's Newsletter* 7 (September–October 1976): 101.

100

I make prints because it is another way to talk. . . . I do not care what it takes to make a print. Real tire tracks seem to me more beautiful than some guy who makes a million marks per square inch on an etching. I hate the weight-lifting, muscle-building aspect of the printmaker. That seems like the invention of the wheel hang-up. I love prints because they are another thing.

> Quoted in Jim Dine, "Prints: Another Thing," *Artist's Proof* 6 (1966): 101.

Although I was able [early on] to draw with a certain degree of efficiency, I denied it. I always wanted to hide it because it wasn't American. It wasn't enough, it wasn't in the Duchamp aesthetic that we all came to revere, which I feel is such an empty one, although very intelligent.

> Quoted in Constance W. Glenn, *Jim Dine Drawings* (New York: Harry N. Abrams, 1985), p. 198.

100. *Toothbrush I,* 1962
Lithograph, 25¼ x 20⅛ in. (64 x 51 cm)

With the show that I had at Sonnabend of the tool drawings [1974], I felt for the first time I could control my hand and make it give me the image I wanted. That show was a true turning point for my work. It began simply out of the urge to draw—to draw and not rely on anything but my ability to communicate through my drawing. . . . It has taken me twenty years to learn how to draw.

Quoted in Thomas Krens, *Jim Dine Prints: 1970–1977* (New York: Harper and Row; Williamstown, Mass.: Williams College, 1977), p. 33.

The skull came from a conversation with a friend in Paris two years ago [1984]. She confided that she and her husband had visited a "channel," a medium who assumed the voice of a person from another world. This gave me the image of the skull, not as a dead person but as a voice coming out. I saw it as the bare bones of me: a self-portrait, not as a *tête de mort* but as the real person.

Quoted in Livingstone, *Rise Up, Solitude!* p. 10.

My work is like me, I think. Definitely, it is me. I am it. I am the work. There is no question about that. I probably am as closely linked to my work as any artist I know. That is, if you know me, you know my work. I'm not closed off in that way.

Quoted in Susie Hennessy, "A Conversation with Jim Dine," *Art Journal* 39 (spring 1980): 174.

Notes on Technique

With some artists, technique can easily be discussed as an issue apart from the main story line of their artistic development. Also, some artists' technique remains consistent over the years, even if their style or subject evolves. The same can be said of the documentation of the artist's life—namely, the now de rigueur chronology that traces family life, travels, studio locations, and the like. For some artists these factors are relatively stable, and their impact on the artist's production minor. Over the course of a lifetime many artists may have only a handful of studios and just a few changes of locales, which may not have any significant impact on their work.

None of the above is true for Jim Dine; in fact, quite the contrary. Technique is inextricably tied to content in his work. The constant movement that has characterized his life relates to his ever-evolving technical skills and his constant search for new opportunities to put his increased knowledge to maximum use. Tracking his movements from one location to another and the projects associated with each frustrates even the most conscientious biographer.

In approaching the subject of Dine and technique, we must first state the obvious. By working in all mediums Dine works with numerous techniques. He is a painter, a sculptor, a printmaker, a draftsman, a set and costume designer, and the creator of illustrated *livres de luxe*. As a painter he works in acrylic and oil and spray paint and automobile enamel. His sculptural materials range from chicken wire to wood to cast aluminum and bronze. As a printmaker he works with all methods, preferring intaglio and woodblock printing but also creating silkscreens, lithographs, and prints that combine two or three processes.

For Dine, there is no hierarchy among these mediums and techniques. Painting is not more important than printmaking; every medium is given equal weight. And whatever medium Dine uses, there are no maquettes, no preparatory sketches, no little studies that leave the studio as sketchbook ideas. Every drawing is a finished, full-blown endeavor. Every sculpture, regardless of scale, is

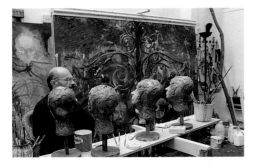

102

101. *Pleasure Palette,* 1969
Glass, paper, and oil on canvas, 59¾ x 40¼ in.
(152 x 102 cm)
Museum Ludwig, Cologne, Germany

102. Dine painting a series of heads of Nancy Dine, with some gate paintings in the background, 1983

a work in its own right. For Dine, understanding the technique is only a starting point. First he masters each medium's technique, then exploits it, undermines it, subverts it, and pushes it forward at every possible opportunity.

In order to do this, to pursue various techniques, he has established a way of life that allows him to continually learn, both on his own and in collaboration with others. He has adopted a peripatetic rhythm that complements his gypsylike resistance to staying in one place too long. So he moves from studio to studio, workshop to workshop, city to city, and many projects in many media in many cities take place simultaneously. Dine gives each his full attention while he is focused on it. But that focus shifts rapidly as he moves wherever necessary to keep the momentum going.

The private work, painting and drawing, he has done in studios and hotel rooms all over the world. The collaborative work of printmaking, sculpture, theater design, and book illustration has taken place at workshops and foundries that crisscross the globe. This pattern began early on. After only a few years in Manhattan, Dine moved to Europe, making his first trip to London to work on print projects in Editions Alecto. While living in Vermont and working regularly with models, he was also spending a great deal of time in Manhattan and later Los Angeles. In Manhattan he turned a suite of rooms in the Stanhope Hotel into a temporary headquarters. In Los Angeles he had the same kind of arrangement at the Biltmore. At the same time as he "resided" at his principal locations of New York, London, and Vermont, he was involved in projects that required extended periods in Aspen, Colorado; Boston; West Islip, New York; Tampa, Florida; Copenhagen; Jerusalem; Paris; Vienna; Cambridge, Massachusetts; Venice; Hanover, New Hampshire; Key West, Florida; Salzburg, Austria; Tokyo; Los Angeles; Chicago; Walla Walla, Washington; Munich; Humlebaek, Denmark; Ithaca, New York; and Washington, Connecticut.

What attracts Dine to these far-flung spots varies. Sometimes it is the romantic lure of the location itself—for instance, a chance to spend the winter months in Venice, when the streets, canals, and churches are empty of tourists. More often than not a visit is tied to an exhibition opportunity, a commission, or an invitation from a workshop that offers him a certain technical expertise and collaborative opportunity. However, the length of the list of locales and collaborators should not imply to the innocent observer that Dine will go wherever or work with anyone. In fact, there is a certain type of atmosphere that he especially seeks out and a certain approach that he demands.

Dine's period of apprenticeship in each medium is unusually short. There are no beginners' prints, no student drawings, no awkward sculptures. Without fear of exaggeration, one can call him a master printmaker, one of the late twentieth century's greatest draftsmen, and the impresario of an immense West Coast foundry. He became all of these by electing to work with people who had the highest level of technical expertise but who did not have a tyrannical approach to applying it. His primary collaborators—Aldo Crommelynck and Donald Saff in printmaking,

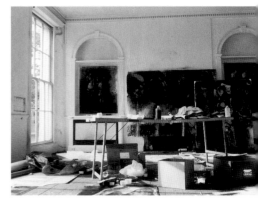

103

103. One of Dine's temporary studios, London, mid-1980s

104. Dine working on plaster Venus at Walla Walla, Washington, mid-1980s

Andrew Hoyem in book illustration, Mark Anderson in bronze casting—know that Dine wants not to be given rules and limits but to be placed in high-energy situations in which many options are presented and experimentation is encouraged. They have to enjoy the flexibility and openmindedness that he desires and be willing to facilitate his fast-paced style of working and his impatient temperament. When Dine approaches a collaborator to learn if something is possible, he does not expect to be told that it is not. Finding solutions is a means toward the creative end. Every rule is meant to be broken, every "mistake" turned into an opportunity.

Dine has an uncanny ability to home in on each workshop's defining property and each collaborator's strength. These he does not change but exploits. If a printer is having difficulty creating an even aquatint, Dine capitalizes on the unevenness (as in *Pine in a* 57 *Storm of Aquatint*). If the printer is such a master of precision that the aquatint reads as a watercolor wash (as in *Desire in Primary* 62 *Colors*), Dine takes full advantage of that, in a different way. Technique becomes a means through which the artist reinvents his image. No process is considered sacrosanct, no surface or material sacred. Plates are there to be attacked with Dremels, canvases to be ripped through with electric sanders, and wood to be hacked at with chain saws. Acid may be applied with a broom as well as a brush. Only through bold experimentation is Dine able to produce the resonance that his theme-and-variation approach demands.

Dine will visit Walla Walla for two weeks, work on several pieces, and leave instructions with Anderson and crew regarding what needs to be done in his absence. While they are preparing for his next visit, he is back in his New York studio painting or producing new prints in Vienna. When he returns six months later to Walla Walla he resumes where he left off, even though there have been a myriad of intervening activities. The flow within each project remains, but ideas and goals carry over from activity to activity, location to location, medium to medium. Because Dine's own involvement encourages an intermingling of activity and intent from project to project—in terms of technical issues as well as emotional reverberations—the boundaries between the mediums blur. What he learns in one situation he applies to the next.

This ignoring of boundaries between mediums was there from the start. In the *Car Crash* performance Dine was a draftsman, actually drawing before the audience. But the "set" was an environmental sculpture. His early "paintings" had objects affixed, from lawnmowers to branches. Drawing was at the heart of his printmaking even before his immersion in that technique. And later on his drawing became so painterly that his large works on paper merit being called paintings on paper.

An illustration of this intermingling of disparate techniques in the service of creating similar emotional impact can be observed by comparing two works, *Fourteen-Color Woodcut Bathrobe* and 105 *Trembling for Color*. Despite their technical dissimilarity, these two 106 pieces bear an uncanny resemblance to one another. One is a woodblock print of a robe, Dine's symbol for masculinity. The other is a bronze sculpture of Venus, his symbol for femininity. Neither is actually wood, yet both began with that material and

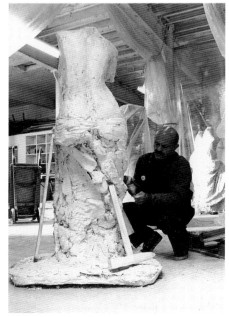

104

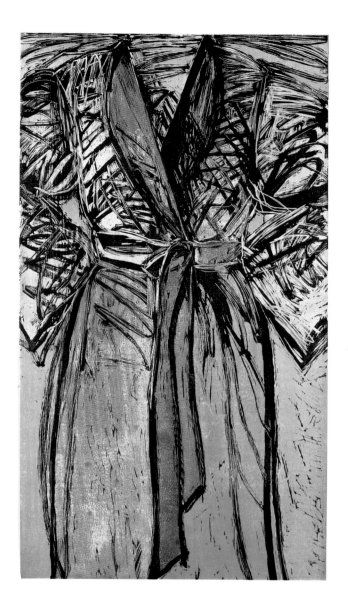

105

retain in their final state reminders of their origin.

In order to make the blockprint Dine utilized a jigsaw-puzzle method that he had learned from scrutinizing Edvard Munch's prints. Dine began by painting a robe on a sheet of plywood and then cutting away the negative space with a power gouge and a Dremel. This accounts for the painterly quality of the printed black "strokes." The robe was traced to another block, with the tracing serving as a guide for its sectional divisions. The sawn block was inked in colors, part by part, reassembled, and printed. The key image block was overprinted in black.

The sculpture began as a block of wood that Dine (with the help of the staff at the Walla Walla Foundry) carved with a chain saw. The torso was hacked into shape, and then the planes were worked

for additional texture. From this piece a rubber mold was made, then a wax positive, and eventually the final bronze. After Dine painted the bronze version so that it appeared to be divided into sections, even though it never was, he wanted to increase the viewer's awareness of the surface texture. With a glove coated with black paint, he wiped down the statue, so that its highest relief, in a manner reminiscent of the robe's key block drawing, appears as black highlights amidst the intense reds, yellows, greens, and blues.

The 77½-inch-long print has a presence that is remarkably sculpturesque. The painted bronze sculpture could be considered a three-dimensional version of a woodcut. Complete command of the working processes of several mediums and a healthy disregard for their conventions led to two unique works of two familiar images. Their audacity exemplifies the technical bravado that gives so much of Dine's art its power of expression.

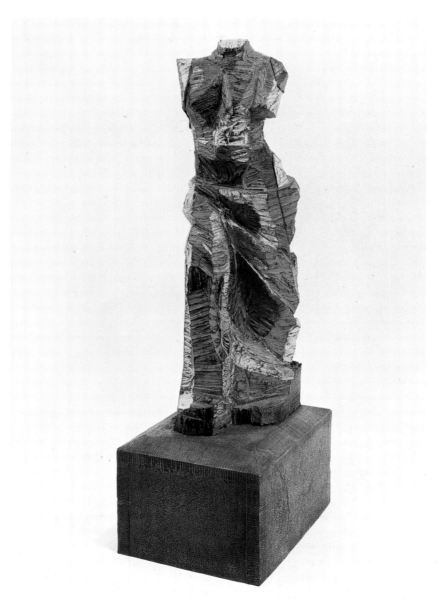

106

Chronology

1935 June 16—James Lewis Dine is born in Cincinnati, Ohio. His father, Stanley, and mother, Eunice, are both second-generation Jewish immigrants from Eastern Europe. Jim Dine later recalls frequent childhood visits to the Cincinnati Art Museum, in particular remembering paintings by Cincinnati artists Frank Duveneck and John Henry Twachtman as well as by the American illusionists John F. Peto and William M. Harnett.

1947 Mother dies. Thereafter he lives mostly with his aunt and uncle or his maternal grandparents.

1948–53 Has first exposure to an artist's studio in 1948, when he takes art classes at the studio of local artist Vincent Taylor. During high school attends evening adult art classes with artist-instructor Paul Chidlaw at the Art Academy of Cincinnati. June 1953—graduates from Walnut Hills High School.

1954–57 After beginning undergraduate studies in graphic design at the University of Cincinnati, transfers as a fine arts major to Ohio University, in Athens, Ohio, taking the fall 1955 semester at the Boston Museum School. June 1957—after receiving his B.F.A. from Ohio University stays on for one year of graduate studies with Frederick Leach. 1954—studies Paul J. Sachs's *Modern Prints and Drawings,* which he later cites as an important reference. Makes several trips to New York City. June 16, 1957—marries Nancy Minto, a fellow Ohio University student.

1958 They move to New York, living first on Long Island, where he teaches art in a public grade school in Patchogue. The next year they move into Manhattan, where he teaches at the private Rhodes School.

1959 With Claes Oldenburg and Marc Rat-

liff, opens the Judson Gallery in the Judson Memorial Church, New York, where he participates in his first New York group exhibitions, *Jim Dine, Marc Ratliff, Tom Wesselmann* and *Dine/Oldenburg.* Joins the Reuben Gallery, along with Red Grooms, Allan Kaprow, Claes Oldenburg, Lucas Samaras, George Segal, and Robert Whitman. First son, Jeremiah, born, followed by Matthew in 1961, and Nicholas in 1965.

1960 February 29–March 2—first performances of *Smiling Workman,* staged in his environment *The House* at Judson Gallery. April—first solo exhibition held at Reuben Gallery, New York; November 1–6—he performs *Car Crash* there. Six *Car Crash* lithographs, his first to be published, are printed by Emiliano Sorini, Pratt Graphic Art Center, New York.

1961 Joins Martha Jackson Gallery and begins working in his studio full-time. Participates in his first European group exhibition, *Modern American Painting,* United States Information Service Gallery, London.

1962 Early in year—has exhibition at Martha Jackson Gallery of paintings of ties and other personal and household objects. First European solo exhibition held at Galleria dell'Ariete, Milan. Meets Ileana Sonnabend, who exhibits his tool paintings with objects at her Paris gallery the following year; Dine maintains an association with Sonnabend for fourteen years. Through Sonnabend meets Robert Rauschenberg and Jasper Johns. Spends summer in East Hampton, and Johns takes him to meet Tatyana Grosman at Universal Limited Art Editions (ULAE), West Islip, New York. September 14—included in special issue of *Life* magazine, subtitled "One Hundred of the Most Important Young Men and Women in the United States: 'The Take-Over Genera-

107. Dine seated on work desk at Walla Walla.

tion.'" Begins psychoanalysis (continues until 1964).

1962–69 Publishes twenty-three lithographic editions at ULAE (plus eight others, 1982–84). His subjects coincide with images he is also exploring in drawings and paintings, such as tools, bathroom-related objects, palettes, and hearts.

1963 Joins Sidney Janis Gallery, New York

1964 Included in XXXII International Biennale, Venice, and biennial at Carnegie Institute, Pittsburgh. Produces first bathrobe images, as paintings and prints. Screenprints are first published—*Awl, Throat,* and *Calico*—for three portfolios, each entitled *11 Pop Artists.*

1965 Works as guest lecturer, Yale University, New Haven, Connecticut, and as artist-in-residence, Oberlin College, Oberlin, Ohio. Makes first cast-aluminum sculptures.

1966 Designs costumes and sets for *A Midsummer Night's Dream* for the San Francisco Actor's Workshop, which includes his first use of the heart image. Spring—travels to London, his first trip abroad. His first portfolio of prints—ten screenprints called *A Tool Box*—is printed by Christopher Prater, Kelpra Studios, Ltd., London, for Editions Alecto. Works as visiting critic, College of Architecture, Cornell University, Ithaca, New York, for academic year 1966–67.

1967 June—moves to London with family, residing first in Battersea Park and then Chester Square. Concentrates on poetry and printmaking. Museum of Modern Art, New York, exhibits his designs for sets and costumes of *A Midsummer Night's Dream.* Participates in Documenta, Kassel, Germany.

1968 Paul Cornwall-Jones establishes Petersburg Press and Dine begins a seven-year affiliation with him, resulting in numerous editions of lithographs and etchings. Visits Paris for the first time.

1969 Publishes a book of his own poems, *Welcome Home Lovebirds.*

1970 Collaborates with Ron Padgett on the book *The Adventures of Mr. and Mrs. Jim and Ron.* February 27—major retrospective opens at the Whitney Museum of American Art, New York. First retrospective of his prints held at Kestner Gesellschaft, Hanover, Germany.

1971 Spring—moves with family to Putney, Vermont, which remains his home base until 1985. During this time also maintains his studio in London and sets up several temporary studios in apartments, houses, and hotels in New York; Los Angeles; Key West and Tampa, Florida; Aspen, Colorado; Hanover, New Hampshire; Walla Walla, Washington; Humlebaek, Denmark; Jerusalem; Chicago; Cambridge, Massachusetts; and Venice. Begins series of large heart paintings.

1973 Summer—meets the master printer Aldo Crommelynck in Paris.

1974 Meets Donald J. Saff, director of Graphicstudio, University of South Florida, Tampa. Produces several editions with Graphicstudio during 1974–75, 1983, and 1986–89.

Fall—is visiting artist at Dartmouth College, Hanover, New Hampshire, where he meets Mitchell Friedman, with whom he will work on his printmaking until 1981. Uses die-grinder as an electric sander or erasing tool for his prints (in 1975 starts using it for line and tone). His solo exhibition at Sonnabend Gallery (in Soho, New York) marks the end of one approach to drawing, as soon thereafter he begins regular sessions of drawing from the model Jessie Heller as well as his wife, Nancy.

1975 Is visiting printmaker, Dartmouth College. Designs interior art for Los Angeles Biltmore Hotel. Resumes psychoanalysis (continues until 1977).

1976 Joins Pace Gallery, New York, an affiliation that continues to the present. Is artist-in-residence at Williams College, Williamstown, Massachusetts. October 3—first major print retrospective in the United States opens at Williams College Museum of Art. Begins to work regularly on prints with Aldo Crommelynck. Begins a series of large, often multipanel robe paintings.

1977 January 15—opens first exhibition with the Pace Gallery, showing paintings, drawings, and etchings of robes, which reflect a change in his work characterized by an increase in scale, greater technical proficiency, and a shift in emotional tenor. July—makes a soft-ground drawing for what evolves into the twenty-five-print series *Nancy Outside in July,* 1978–81, published by Atelier Crommelynck. Begins series of still-life paintings that feature glass bottles, ceramic objects, vegetables, a souvenir statue of the Venus de Milo, a skull, shells, and other objects.

108

108. Dine, London, 1960s

109. Dine working on van Gogh drawings, 1983

1979 Spring–summer—completes eighteen editions at Burston Graphic Center, Jerusalem (returns to the center for short periods in 1980 and 1981).

1980 First uses the Dremel (an electric tool) extensively, for his Strelitzia print series. Continues to experiment with a variety of power tools and gradually incorporates them into his drawing and painting techniques as well as printmaking. Elected to the American Academy and Institute of Arts and Letters, New York. Sets up a London studio at Sydney Close, which he still maintains. Begins to explore the tree image in depth in paintings and works on paper.

1981 First uses the image of the wrought-iron gate at the entrance to the Crommelynck workshop; returns to using the heart as well.

1982 Begins serious involvement with bronze casting, first in London with the Venus figure, which he begins to explore in depth in printmaking as well. Meets Mark Anderson, director of Walla Walla Foundry, Walla Walla, Washington; subsequently produces most of his sculpture there. To facilitate his regular visits to the foundry purchases (in 1988) a small church that he converts into a living space with painting studio. Spends summer in Copenhagen completing eighteen-panel commission, *Lessons in Nuclear Peace*, for library of Louisiana Museum, Humlebaek, Denmark. Creates twenty-nine woodblock prints for *The Apocalypse: The Revelation of Saint John the Divine*, published by Arion Press, San Francisco, with which he develops an ongoing relationship.

1983 During first half of the year makes several visits to Los Angeles, where he casts in bronze *The Crommelynck Gate with Tools* at Otis Art Institute of Parsons School of design. Creates series of drawings after van Gogh in temporary studio at Biltmore Hotel, Los Angeles. Creates second group of large gate paintings.

1984 February 19—major retrospective opens at Walker Art Center, Minneapolis. Visits Munich for the first time.

1985 Paints large mural for John Nuveen and Company, Chicago, which incorporates all his signature themes: robe, heart, Venus, tree, and gate. A larger-than-life bronze sculpture, *Howard Street Venus,* is commissioned by the Redevelopment Agency of San Francisco, to be placed in Convention Plaza. Fall—leaves Vermont and sets up studios in Washington state, Connecticut, and New York (first in the West Village, later in Soho, and, as of 1992, in Tribeca). Increases the amount of time he travels away from his home base in New York, with frequent trips to Europe (Verona, Italy; London; Paris; Munich and Berlin; and Vienna and Salzburg, Austria) and Walla Walla. At age fifty resumes psychoanalysis.

109

1986 January 22—second major print retrospective opens, at Wesleyan University, Middletown, Connecticut. Travels to Japan for his first exhibition of paintings and drawings in Asia, at Fuji Television Gallery, Tokyo. Designs sets and costumes for Houston Grand Opera's 1986–87 season presentation of Richard Strauss's *Salome,* directed by Francesca Zambello. Spends November through January 1987 in Venice (returns there in late 1987 and stays through early 1988).

1987 *The Boston Double Venus* sculpture commissioned by Graham Gund for Bulfinch Triangle, North Station, Boston. Begins a series of drawings based on classical sculptures in the Glyptothek, Munich.

1988 September 3—major retrospective opens at Galleria d'Arte Moderna Ca'Pesaro, Venice. *The Cincinnati Venus* sculpture commissioned by Tipton Associates for Centennial Plaza, Cincinnati.

1989 *Looking toward the Avenue* sculpture commissioned by Tishman Speyer Trammell Crow Limited Partnership for 1301 Avenue of the Americas, New York. *East End Venus* sculpture commissioned by Rosehaugh Stanhope Developments PLC for Broadgate, London. *At the Wedding* painting commissioned for Seibu Department Store, Tokyo.

1990 October 25—first major retrospective in Asia opens at the Isetan Museum of Art, Tokyo.

1991 Begins exploring the theme of an embracing cat and ape, based on mid-nine-

teenth-century English porcelain figurine.

1992 Nancy Dine produces film *Jim Dine: Childhood Stories,* documenting the artist's early life. Dine receives the Pyramid Atlantic Award of Distinction, Washington, D.C.

1993 August—teaches at the International Summer Academy, Salzburg, Austria (again in 1994).

1994 Spends early part of year in Vienna. Creates wall drawing installation for Kunstverein Ludwigsburg, Ludwigsburg, Germany. Exhibits his botanical drawings as a group for the first time at Pace Gallery.

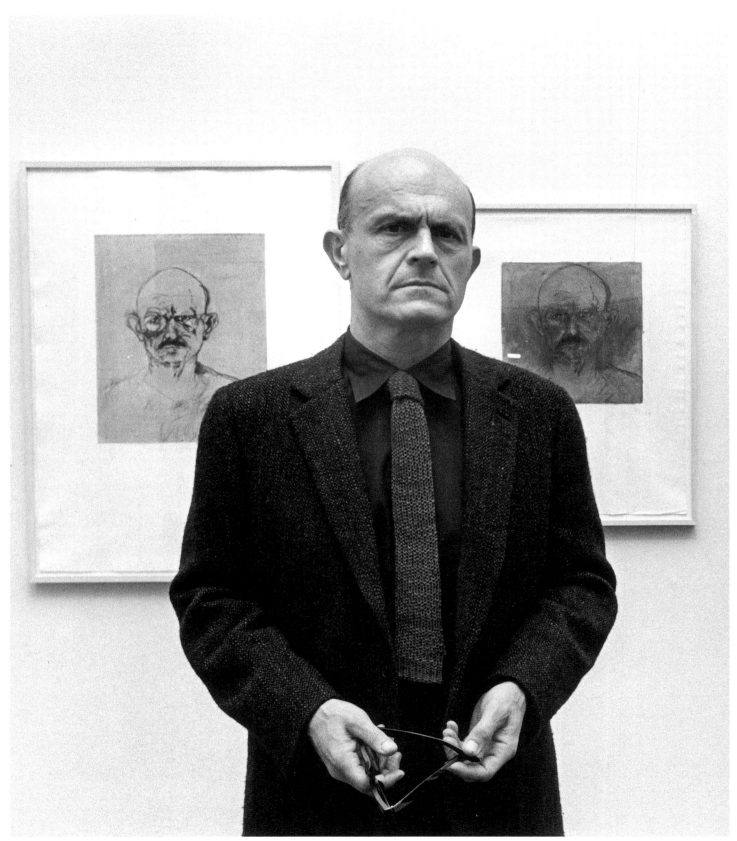

Exhibitions

Selected Solo Exhibitions

1960
Jim Dine, Reuben Gallery, New York, April 1–14.

1962
Jim Dine: New Works, Martha Jackson Gallery, New York, January 9–February 3.
 Galleria dell'Ariete, Milan, October.

1963
Jim Dine, Sidney Janis Gallery, New York, February 4–March 2.
 Jim Dine, Galerie Ileana Sonnabend, Paris.
 Galerie Rudolf Zwirner, Cologne, West Germany.
 Palais des Beaux-Arts, Brussels.

1964
Jim Dine, Sidney Janis Gallery, New York, October 27– November 21.

1965
Jim Dine, Recent Paintings, Robert Fraser Gallery, London, June 1–July 3.
 Galleria Gian Enzo Sperone, Turin, Italy, October 23–November 25.
 Jim Dine: Artist in Residence, Allen Memorial Art Gallery, Oberlin College, Oberlin, Ohio, November 3–24.

1966
New Paintings, Sculpture, and Drawings by Jim Dine, Sidney Janis Gallery, New York, November 1–26.

1967
Nancy and I at Ithaca: Jim Dine, Andrew Dickson White Museum of Art, Cornell University, Ithaca, New York, April 8–30.
 Jim Dine, Galerie Rolf Ricke, Kassel, West Germany, April 15–May 19.

Jim Dine Designs for "A Midsummer Night's Dream," Museum of Modern Art, New York, August 8–September 24.

1969
Galerie Ileana Sonnabend, Paris.
 Robert Fraser Gallery, London.

1970
Jim Dine, Whitney Museum of American Art, New York, February 27–April 19.
 Jim Dine, Sonnabend Gallery, New York, February 28–March 28.
 Projets de décors et costumes pour "A Midsummer Night's Dream," "The Picture of Dorian Gray," Palais des Beaux-Arts, Brussels, May 12–June 14.
 Jim Dine: Complete Graphics, Kestner-Gesellschaft, Hanover, Germany, and tour to Galerie Mikro, Berlin, and Galerie van de Loo, Munich.

1971
Jim Dine: Schildijn, Aquarelle, Objekten en het Completo Grafische Oeuvre, Museum Boymans–van Beuningen, Rotterdam, February 20–April 12.
 Jim Dine: Gemalde, Aquarelle, Objekte, Graphik, Stadtische Kunsthalle Düsseldorf, April 4–June 6.
 Jim Dine: Graphik Neue Folgen und Einzelblatter Ferner wichtige Mappenwerke und Einzelblatter aus dem Jahren 1960–1968, Galerie der Spiegel, Cologne, West Germany. April 16–May 18.
 Jim Dine, Kunsthalle Bern, June 16–July 21.
 Jim Dine: Gemalde, Aquarelle, Objekte, Staatliche Kunsthalle Baden-Baden, Baden-Baden, West Germany, October 8–November 11.

1972
Jim Dine: Bilder, Collages, Skulpturen, 1962–1972, Galerie Gimpel und Hanover, Zurich, September 22–October 25.

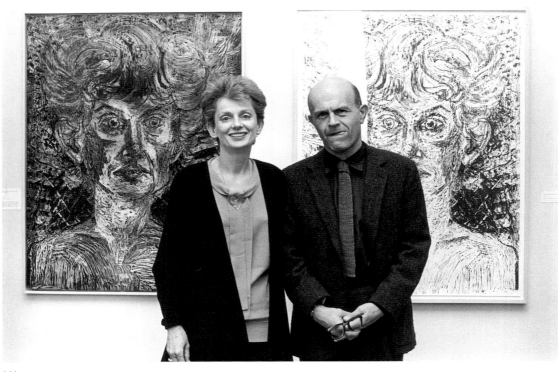

111

Jim Dine: Estampes originales, livres illus-trés, divers, Galerie Gerald Cramer, Paris, November 1972–January 1973.

Galerie Ileana Sonnabend, Paris.

1973

Jim Dine: Seven New Paintings, Gimpel Fils, London, October 30–November 24.

Sonnabend Gallery, New York.

1974

Jim Dine Prints, Institute of Contemporary Art, London, October 9–24.

Galerie Ileana Sonnabend, Geneva.

Sonnabend Gallery, New York.

1975

Jim Dine, Centre des Arts Plastiques Contemporains, Bordeaux, France, May 20–July 15.

1976

Jim Dine Prints: 1970–1977, Williams College Museum of Art, Williamstown, Massachusetts, October 3–November 5, and tour to Hayden Gallery, Massachusetts Institute of Technology, Cambridge; Johnson Gallery, Middlebury College, Middlebury, Vermont; University Art Gallery, State University of New York, Albany; Herbert F. Johnson Museum of Art, Cornell University, Ithaca, New York.

1977

Jim Dine: Paintings, Drawings, Etchings, 1976, Pace Gallery, New York, January 15–February 12.

Jim Dine, Galleria Civica d'Arte Moderna, Ferrara, Italy, October 31–January 3, 1978.

1978

Jim Dine: New Paintings, Pace Gallery, New York, April 29–June 9.

Jim Dine's Etchings, Museum of Modern Art, New York, June 6–September 5, and tour to Toledo Museum of Art, Toledo, Ohio; Tacoma Art Museum, Tacoma, Washington; Baltimore Museum of Art; Cincinnati Art Museum; Sala Mendoza, Caracas, Venezuela.

1979

Jim Dine: Oeuvre sur papier, 1978–1979, Galerie Claude Bernard, Paris, October 2–November 3.

Jim Dine: Figure Drawings, 1975–79, University Art Museum, California State University, Long Beach, October 15–November 11, and tour to Helen Foresman Spencer Museum of Art, University of Kansas, Lawrence; Reed College, Portland, Oregon; Boise Gallery of Art, Boise, Idaho; Springfield Art Museum, Springfield, Missouri; Arkansas Arts Center, Little Rock.

Jim Dine: "Portraits," Works on Paper, Galerie Alice Pauli, Lausanne, Switzerland, November–January 1980.

1980

Jim Dine, Pace Gallery, New York, January 11–February 9.

Jim Dine, Harcus/Krakow Gallery, Boston, April 12–May 14.

1981

Jim Dine: An Exhibition of Recent Figure Drawings, 1978–80, Richard Gray Gallery, Chicago, January 24–March 7.

Jim Dine "Trees," Galerie Isy Brachot, Brussels, October 29–November 28.

Jim Dine: Recent Work, Pace Gallery, New York, November 6–December 5.

1982

Jim Dine: Paintings, Watercolors, Waddington Galleries, London, June 29–July 24.

Jim Dine: Drawings and Prints, Thorden Wetterling Gallery, Gothenberg, Sweden, September 27–October 24.

1983

Jim Dine: New Paintings and Figure Drawings, Richard Gray Gallery, Chicago, February 5–March 19.

Jim Dine: Gravures et Monotypes, Galerie Alice Pauli, Lausanne, Switzerland, April 29–June 4.

Centric 8: Jim Dine, The Apocalypse: The Revelation of Saint John the Divine, University Art Museum, California State University, Long Beach, June 3–26.

Jim Dine in Los Angeles, Los Angeles County Museum of Art, September 8–October 9.

Nancy Outside in July: Etchings by Jim Dine, Art Institute of Chicago, October 26–December 10, and tour to Museum of Fine Arts, Boston.

1984

Jim Dine: 1959–63, Sonnabend Gallery, New York, January 7–28.

Jim Dine: Sculpture and Drawings, Pace Gallery, New York, February 17–March 17.

Jim Dine: Five Themes, Walker Art Center, Minneapolis, February 19–April 15, and tour

to Phoenix Art Museum; Saint Louis Art Museum; Akron Art Museum, Akron, Ohio; Albright-Knox Art Gallery, Buffalo, New York; Hirshhorn Museum and Sculpture Garden, Smithsonian Institution, Washington, D.C.

Jim Dine: Recent Paintings and Sculpture, Richard Gray Gallery, Chicago, May 5–June 9.

Jim Dine: Paintings and Drawings, Thorden Wetterling Gallery, Stockholm, November 8–January 5, 1985.

1985

Jim Dine, Looking in the Dark, Richard Gray Gallery, Chicago, September 21–October 25.

1986

Jim Dine: Paintings, Drawings, and Sculpture, Pace Gallery, New York, January 17–February 15.

Jim Dine Prints, 1977–1985, Davison Art Center and the Ezra and Cecile Zilkha Gallery, Wesleyan University, Middletown, Connecticut, January 22–March 9, 1986, and tour to Archer M. Huntington Art Gallery, University of Texas at Austin; Los Angeles County Museum of Art; Toledo Museum of Art, Toledo, Ohio; Des Moines Art Center, Des Moines, Iowa; Nelson-Atkins Museum of Art, Kansas City, Missouri; University Gallery, Memphis State University, Memphis, Tennessee; Williams College Museum of Art, Williamstown, Massachusetts.

Jim Dine: Rise Up, Solitude! Prints, 1985–86, Waddington Graphics, London, February 5–March 1.

Jim Dine: Monoprints and Sculptures, Galerie Kaj Forsblom, Helsinki, Finland, March 3–April 4.

Jim Dine, Fuji Television Gallery, Tokyo, September 5–October 4.

Jim Dine: Peintures et sculptures, Galerie Alice Pauli, Lausanne, Switzerland, November 27–January 3, 1987.

1988

Jim Dine: New Paintings, Pace Gallery, New York, February 5–March 5.

Drawings: Jim Dine, 1970–1987, Contemporary Arts Center, Cincinnati, March 11–May 7, and tour to Museum of Art, Fort Lauderdale, Florida; Santa Barbara Museum of Art, Santa Barbara, California; Henry Art Gallery, University of Washington, Seattle; Modern Art Museum of Fort Worth; Minneapolis Institute of Arts; Arts Club of Chicago; Joslyn Art Museum, Omaha; M. H. de Young Memorial Museum, San Francisco.

Jim Dine: Paintings, Sculpture, Drawings, Prints, 1959–87, Galleria d'Arte Moderna Ca'Pesaro, Venice, September 3–November 6.

1989

Jim Dine: "Youth and the Maiden" and Related Works, Graphische Sammlung Albertina, Vienna, January 11–February 26.

Jim Dine: Prints and Drawings, Museum of Fine Arts, Boston, July 22–September 27.

1990

Jim Dine in der Glyptothek, Staatliche Antikensammlungen und Glyptothek, Munich, January 21–March 25, and tour to Ny Carlsberg Glyptothek, Copenhagen; Nelson-Atkins Museum of Art, Kansas City, Missouri.

Jim Dine Drawings, Pace Gallery, New York, February 16–March 17.

Jim Dine, Isetan Museum of Art, Tokyo, October 25–November 20, and tour to Museum of Art, Osaka.

1991

Jim Dine: Trembling for Color, Galerie Beaubourg, Paris, February–March.

Jim Dine, Hakone Open-Air Museum, Hakone-machi, Japan, April 19–May 7.

Jim Dine: New Paintings and Sculpture, Pace Gallery, New York, September 21–October 26.

1992

Jim Dine, Galerie Alice Pauli, Lausanne, Switzerland, March 6–May 9.

Jim Dine, Kujke Gallery, Seoul, South Korea, October 27–November 25.

1993

Jim Dine: Paintings, Sculpture, Galleri Haaken, Oslo, March 24–June 20.

Jim Dine: New Paintings, Richard Gray Gallery, Chicago, May 7–June 12.

Jim Dine: Drawings from the Glyptothek, Madison Art Center, Madison, Wisconsin, April 17–June 13, and tour to Cincinnati Art Museum; Contemporary Museum, Honolulu; Montreal Museum of Fine Arts; Center for the Fine Arts, Miami.

Jim Dine: Ape and Cat, Pace Gallery, New York, October 22–November 27.

Jim Dine: Drawings, Paintings, and Sculpture of the 1980s, Boras Konstmuseum, Boras, Sweden, November 7–February 20, and tour to Ludwig Museum, Budapest; Musée d'Art Moderne et d'Art Contemporain, Nice.

1994

Jim Dine: Wall Drawings, Kunstverein Ludwigsburg, Ludwigsburg, Germany, March 27–May 8.

Jim Dine: Flowers and Plants, Pace Gallery, New York, September 16–October 15.

Selected Group Exhibitions

1959

Jim Dine, Marc Ratliff, Tom Wesselmann, Judson Gallery, New York, February 14–March 7.

Dine/Oldenburg, Judson Gallery, New York, November 13–December 3.

Below Zero, Reuben Gallery, New York, December 18–January 5, 1960.

1960

Paintings, Reuben Gallery, New York, January 29–February 18.

The House and the Street, Judson Gallery, New York, January 30–March 17 (with Claes Oldenburg).

New Media—New Forms I, Martha Jackson Gallery, New York, June 6–24.

New Media—New Forms II, Martha Jackson Gallery, New York, September 28–October 22.

1961

Environments, Situations, Spaces, Martha Jackson Gallery, New York, May 25–June 23.

1962

New Paintings of Common Objects, Pasadena Museum, Pasadena, California.

The New Realists, Sidney Janis Gallery, New York, October 31–December 1.

Third International Biennial Exhibition of Prints, National Museum of Modern Art, Tokyo.

1963

Six Painters and the Object, Solomon R. Guggenheim Museum, New York, March 14–June 2.

The Popular Image, Washington Gallery of Modern Art, Washington, D.C., April 18–June 2.

Mixed Media and Pop Art, Nelson Gallery of Art, Kansas City, Missouri.

1964

Four Environments by Four Realists, Sidney Janis Gallery, New York, January 1–February 1.

XXXII Biennale Internazionale d'Arte, United States Pavilion, Venice, June 20–October 15. Also included in 1970 and 1972.

American Pop Art, Stedelijk Museum, Amsterdam.

Pittsburgh International Exhibition of Contemporary Painting and Sculpture, Museum of Art, Carnegie Institute, Pittsburgh. Also included in 1967.

1965

Pop Art and the American Tradition, Milwaukee Art Center, April 9–May 9.

Whitney Annual, Whitney Museum of American Art, New York, December 8–January 1966. Also included in 1966, 1967, and 1973.

1967

Dine, Oldenburg, Segal, Art Gallery of

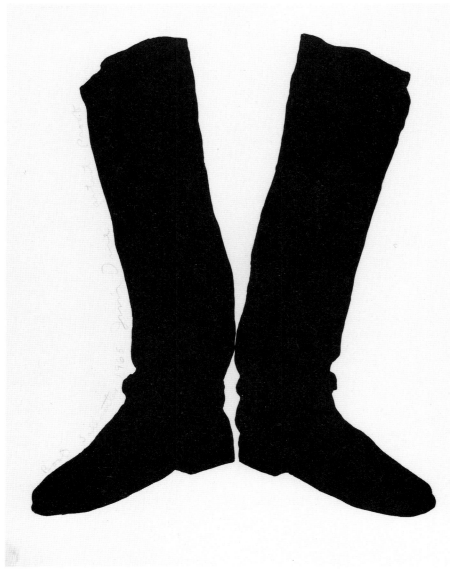

112

Ontario, Toronto, January 14–February 12, and tour.

1968
Documenta IV, Kassel, West Germany, June 27–October 6. Also included in 1977.

1969
Prints by Five New York Painters: Jim Dine, Roy Lichtenstein, Robert Rauschenberg, Larry Rivers, James Rosenquist, Metropolitan Museum of Art, New York, October 18–December 8.

1971
American Art: 1950–1970, Louisiana Museum of Modern Art, Humlebaek, Denmark.

1973
Dine, Kitaj—A Two-Man Exhibition, Cincinnati Art Museum, April 12–May 13.

1976
Thirty Years of American Printmaking, Brooklyn Museum, November 20–January 30, 1977.
 The Human Clay, Hayward Gallery, London.

1977
Drawings of the Seventies, Art Institute of Chicago.

1980
American Image: 1960–1980, Palazzo Grassi, Venice.
 The Painterly Print: Monotypes from the Seventeenth to the Twentieth Century, Metropolitan Museum of Art, New York, October 16–November 7, and tour.
 Twenty American Artists, San Francisco Museum of Modern Art.

1981
*The Image in American Painting and Sculp-

ture, 1950–1980*, Akron Art Museum, Akron, Ohio, September 12–November 8.

1984
Drawings, 1974–1984, Hirshhorn Museum and Sculpture Garden, Smithsonian Institution, Washington, D.C., March 15–May 13.
 Blam! The Explosion of Pop, Minimalism and Performance, 1958–64, Whitney Museum of American Art, New York, September 20–December 2.
 Ten Painters and Sculptors Draw, Museum of Fine Arts, Boston.

1987
Contemporary American Stage Design, Milwaukee Art Museum, Milwaukee, Wisconsin.

1989
Painters for the Theater, Museum of Modern Art, New York, July 14–October 18.

1991
Seven Master Printmakers: Innovations in the Eighties, Museum of Modern Art, New York, May 16–August 13.
 The Pop Art Show, Royal Academy of Arts, London, September 13–December 15, and tour.
 Graphicstudio: Contemporary Art from the Collaborative Workshop of the University of South Florida, National Gallery of Art, Washington, D.C., September 15–January 5, 1992.

1992
The Living Object: The Art Collection of Ellen H. Johnson, Allen Memorial Art Museum, Oberlin College, Oberlin, Ohio, March 6–May 25.
 Hand-Painted Pop: American Art in Transition, 1955–62, Museum of Contemporary Art, Los Angeles, December 6–March 7, 1993, and tour.

1993
Sept maîtres de l'estampe: Innovations des années 80 aux Etats-Unis, Musée d'Art Moderne et d'Art Contemporain, Nice, France, January 22–March 14.
 The Portrait Now, National Portrait Gallery, London, November 19–February 6, 1994.

Public Collections

113

112. *Boots Silhouettes,* 1965
Lithograph, 41⅜ x 29½ in. (105 x 75 cm)

113. *Ties,* 1961
Charcoal on paper, 24¼ x 19¼ in. (61.6 x 49 cm)
Private collection

Aichi, Japan, Aichi Prefectural Museum
Akron, Ohio, Akron Art Museum
Amsterdam, the Netherlands, Stedelijk
Museum
Atlanta, Georgia, High Museum of Art
Baltimore, Maryland, Baltimore Museum of
Art
Bloomington, Indiana, Indiana University Art
Museum
Boston, Massachusetts, Museum of Fine Arts
Brooklyn, New York, Brooklyn Museum
Buffalo, New York, The Albright-Knox Art
Gallery
Cambridge, Massachusetts, Fogg Art
Museum, Harvard University
Chicago, Illinois, Art Institute of Chicago
Chicago, Illinois, Museum of Contemporary
Art
Cincinnati, Ohio, Cincinnati Art Museum
Cleveland, Ohio, Cleveland Museum of Art
Cologne, Germany, Museum Ludwig
Dallas, Texas, Dallas Museum of Art
Dayton, Ohio, Dayton Art Institute
Detroit, Michigan, Detroit Institute of Arts
Eindhoven, the Netherlands, Stedelijk van
Abbemuseum
Fort Worth, Texas, Modern Art Museum of
Fort Worth
Humlebaek, Denmark, Louisiana Museum of
Modern Art
Indianapolis, Indiana, Indianapolis Museum
of Art
Jerusalem, Israel, Israel Museum
Kyungsangbuk-Do, South Korea, Sonje
Museum of Contemporary Art
La Jolla, California, San Diego Museum of
Contemporary Art
London, England, Tate Gallery
Los Angeles, California, Douglas Cramer
Foundation
Los Angeles, California, Los Angeles County
Museum of Art
Minneapolis, Minnesota, Minneapolis
Institute of Arts
Minneapolis, Minnesota, Walker Art Center

New Haven, Connecticut, Yale University Art
Gallery
New Orleans, Louisiana, New Orleans
Museum of Art
New York, New York, Jewish Museum
New York, New York, Metropolitan Museum
of Art
New York, New York, Museum of Modern
Art
New York, New York, Solomon R.
Guggenheim Museum
New York, New York, Whitney Museum of
American Art
Oberlin, Ohio, Allen Memorial Art Museum,
Oberlin College
Paris, France, Centre Georges Pompidou,
Musée National d'Art Moderne
Perth, Australia, Western Australian Art
Gallery
Pittsburgh, Pennsylvania, Carnegie Museum
of Art
Princeton, New Jersey, Princeton University
Art Museum
Providence, Rhode Island, Museum of Art,
Rhode Island School of Design
Richmond, Virginia, Virginia Museum of Fine
Arts
Saint Louis, Missouri, City Art Museum
San Francisco, California, San Francisco
Museum of Modern Art
Stockholm, Sweden, Moderna Museet
Toledo, Ohio, Toledo Museum of Art
Toronto, Canada, Art Gallery of Ontario
Waltham, Massachusetts, Rose Art Museum,
Brandeis University
Washington, D.C., Hirshhorn Museum and
Sculpture Garden, Smithsonian Institution
Washington, D.C., National Gallery of Art
Washington, D.C., National Museum of
American Art, Smithsonian Institution
Wellesley, Massachusetts, Wellesley College
Museum
Williamstown, Massachusetts, Williams
College Museum of Art
Wilmington, Delaware, Delaware Art Museum

Selected Bibliography

Interviews, Statements, and Writings

Dine, Jim. "What Is Pop Art? Part I." Interview with G. R. Swenson in *Artnews* 62 (November 1963): 25, 61–62.

———. "All Right Jim Dine, Talk!" Interview with John Gruen, *World Journal Tribune Sunday Magazine*, November 20, 1966.

———. "Prints: Another Thing." *Artist's Proof* 6 (1966): 101.

———. "Test in Art." Interview with Kenneth Koch. *Artnews* 65 (October 1966): 54–57.

———. "Jim Dine's Red Mural for the U.S. Pavilion." Interview with William C. Lipke in *Artscanada* 24 (October 1967): supplement p. 10.

———. "Lithographs and Original Prints: Two Artists Discuss Their Recent Work." *Studio International* 175 (June 1968): supplement p. 337.

———. *Welcome Home Lovebirds*. London: Trigram Press, 1969. Poetry and illustrations by the artist.

———. "Jim Dine at 40." Interview with Frank Robinson and Michael Shapiro in *Print Collector's Newsletter* 7 (September–October 1976): 101–5.

———. "Jim Dine: From My Heart to My Hand." Interview with Adrian Dannatt, *Flash Art* 24 (March–April 1991): 88–93.

Hennessy, Susie. "A Conversation with Jim Dine." *Art Journal* 39 (spring 1980): 168–75.

Smilansky, Noemi. "An Interview with Jim Dine." *Print Review* 12 (1980): 55–61.

Illustrated Books

Dine, Jim. *The Apocalypse: The Revelation of Saint John the Divine*. San Francisco: Arion Press, 1984. 29 woodcuts by Jim Dine.

———. *Temple of Flora*. San Francisco: Arion Press, 1984. 29 etchings by Jim Dine; text by Glenn Todd and Nancy Dine.

———. *The Case of the Wolf-Man*. San Francisco: Arion Press, 1993. 5 etchings and woodcuts by Jim Dine; text by Sigmund Freud, with an introduction by Richard Wollheim.

Dine, Jim, and Lee Friedlander. *Work from the Same House*. London: Trigram Press, 1969. Paperback version of original limited-edition portfolio of photographs by Friedlander and etchings by Dine.

Dine, Jim, and Ron Padgett. *The Adventures of Mr. and Mrs. Jim and Ron*. New York: Cape Goliard Press in association with Grossman Publishers, 1970. Poetry by Padgett with illustrations by Dine.

Monographs and Solo-Exhibition Catalogs

Ackley, Clifford. *Nancy Outside in July: Etchings by Jim Dine*. West Islip, N.Y.: ULAE, 1983. Includes brief statements by the artist, Nancy Dine, and Aldo Crommelynck, and essay by Ackley.

Allen, Virginia. *Jim Dine Designs for "A Midsummer Night's Dream."* New York: Museum of Modern Art, 1968.

Alloway, Lawrence, and Allan Kaprow. *New Forms—New Media I*. New York: Martha Jackson Gallery, 1960.

Beal, Graham W. J., with contributions by Robert Creeley, Jim Dine, and Martin Friedman. *Jim Dine: Five Themes*. New York: Abbeville Press; Minneapolis: Walker Art Center, 1984. Includes artist's commentary about individual works.

Castelman, Riva. *Jim Dine's Etchings*. New York: Museum of Modern Art, 1978.

114. *Books on the Priest's Shelf*, 1990
Painted bronze, 64½ x 29½ x 19 in. (164 x 75 x 48 cm)
Private collection

Codognato, Attilio, and David Shapiro, Carter Ratcliff, and Marco Livingstone. *Jim Dine.* Milan: Nuove Edizioni Gabriele Mazzotta, 1988. Catalog for exhibition at Galleria d'Arte Moderna Ca'Pesaro, Venice.

D'Oench, Ellen G., and Jean E. Feinberg. *Jim Dine Prints, 1977–1985.* New York: Harper and Row; Middletown, Conn.: Wesleyan University, 1986. Fully illustrated print catalogue raisonné for 1977–85, including chronology of printmaking history, extensive bibliography, and essays by D'Oench and Feinberg.

Fahlstrom, Oyvind. *New Paintings by Jim Dine.* New York: Sidney Janis Gallery, 1963.

Finch, Christopher. *Jim Dine: Gemalde, Aquarelle, Objekte.* Berlin: Nationalgalerie, 1971.

Fine, Ruth. *Drawings from the Glyptothek.* New York: Hudson Hills Press, 1993. Includes statement by the artist and essay by the author.

Friedman, Martin. *Jim Dine: New Paintings and Sculpture.* New York: Pace Gallery, 1991. Includes interview with the artist.

Glenn, Constance W. *Jim Dine: Figure Drawings, 1975–1979.* Long Beach: Art Museum and Galleries, California State University; New York: Harper and Row, 1979. Includes interview with the artist.

———. *Centric 8: Jim Dine, The Apocalypse: The Revelation of Saint John the Divine.* Long Beach: University Art Museum, California State University, 1983.

———. *Jim Dine Drawings.* New York: Harry N. Abrams, 1985. Extensive interview with the artist and statements by the artist.

Gordon, John. *Jim Dine.* New York: Praeger Publishers; Whitney Museum of American Art, 1970. Brief statement by the artist, prose poem by Ron Padgett, and early exhibition list and bibliography.

Jim Dine. New York: Sidney Janis Gallery, 1964.

Jim Dine. New York: Sidney Janis Gallery, 1966.

Jim Dine. London: Gimpel Fils, 1973.

Jim Dine. Bordeaux, France: Centre d'Art Plastiques Contemporains de Bordeaux, 1975.

Jim Dine: Paintings, Drawings, Etchings, 1976. New York: Pace Gallery, 1977.

Jim Dine: Paintings, Drawings, Etchings, 1976. London: Waddington and Tooth Galleries II, 1977.

Jim Dine: New Paintings. New York: Pace Gallery, 1978.

Jim Dine: Oeuvres sur papier, 1978–79. Paris: Galerie Claude Bernard, 1980.

Jim Dine: Recent Work. New York: Pace Gallery, 1981. Brief statement by the artist.

Jim Dine: New Paintings and Figure Drawings.

Chicago: Richard Gray Gallery, 1983. Brief statement by the artist.

Jim Dine. London: Waddington Galleries, 1984.

Jim Dine: Looking in the Dark. Chicago: Richard Gray Gallery, 1985.

Jim Dine: Paintings, Drawings, Sculptures. New York: Pace Gallery, 1986. Includes statement by the artist.

Jim Dine: Drawings. New York: Pace Gallery, 1990.

Jim Dine: The Hand-Coloured Viennese Hearts, 1987–90. New York: Pace Prints and Waddington Graphics, 1990.

Jim Dine. Seoul, South Korea: Kukje Gallery, 1992.

Jim Dine: New Paintings. Chicago: Richard Gray Gallery, 1993.

Jouffroy, Alain, and Gillo Dorfles, Lawrence Alloway, and Nicolas Calas. *Jim Dine.* Paris: Galerie Ileana Sonnabend, 1963.

Kitaj, R. B. *Jim Dine: Works on Paper, 1975–76.* London: Waddington and Tooth Galleries II, 1977.

Krens, Thomas, ed. *Jim Dine Prints: 1970–1977.* New York: Harper and Row; Williamstown, Mass.: Williams College, 1977. Fully illustrated print catalogue raisonné of 1970–77, including interview with the artist, biography, and bibliography.

Livingstone, Marco, ed. *Jim Dine.* Osaka, Japan: Art Life, Ltd.; National Museum of Art, 1990.

———. *Rise Up, Solitude! Prints 1985–86.* New York: Pace Prints, 1986. Includes interview with the artist.

———. *Jim Dine: Flowers and Plants.* New York: Harry N. Abrams, 1994.

McHenry, Deni McIntosh. *Jim Dine: Glyptothek Drawings.* Kansas City, Missouri: Nelson-Atkins Museum of Art, 1990.

Mellow, James R. *Jim Dine.* New York: Pace Gallery, 1980.

New Paintings, Sculptures, and Drawings by Jim Dine. New York: Sidney Janis Gallery, 1966.

Oberhuber, Konrad, and Donald Saff. *Jim Dine: "Youth and the Maiden."* Vienna: Graphische Sammlung Albertina, 1989.

Paparoni, Demetrio. *Jim Dine.* London: Waddington Graphics, 1989.

Ratcliff, Carter. *Jim Dine: New Paintings.* New York: Pace Gallery, 1988.

Rogers-Lafferty, Sarah. *Drawings: Jim Dine, 1973–1987.* Cincinnati: Contemporary Arts Center, 1988. Includes biography and extensive bibliography.

Russell, John, Tony Towle, and Wieland Schmied. *Jim Dine: Complete Graphics.* Berlin:

Galerie Mikro, 1970. Fully illustrated print catalogue raisonné.

Schefer, Jean-Louis. *Jim Dine: Trembling for Color.* Paris: L'Autre Musée/Grandes Monographies; Editions de la Différence/Galerie Beaubourg, 1991.

Schmied, Wieland. *Jim Dine.* Hanover, West Germany: Kestner-Gesellschaft, 1970.

Schmied, Weiland, Klaus Vierneisel, and Wilhelm Warning. *Jim Dine in der Glyptothek.* Munich: Staatliche Antikensammlungen und Glyptothek, 1990.

Shapiro, David. *Jim Dine: Painting What One Is.* New York: Harry N. Abrams, 1981. Includes interview with the artist, statements by the artist, full biography, and bibliography.

———. *Jim Dine: Recent Figure Drawings, 1978–1980.* Chicago: Richard Gray Gallery, 1981.

Schapiro, Michael Edward. *The Methods and Metaphors: The Sculpture of Jim Dine.* New York: Pace Gallery, 1984.

Tuchman, Maurice. *Jim Dine in Los Angeles.* Los Angeles: Los Angeles County Museum of Art, 1983.

Periodicals, Books, and Group-Exhibition Catalogs

Ackley, Clifford S. "Face in a Frame." *Artnews* 81 (summer 1982): 63–64.

———. *Ten Painters and Sculptors Draw.* Boston: Museum of Fine Arts, 1984.

Alloway, Lawrence. *Six Painters and the Object.* New York: Solomon R. Guggenheim Museum, 1963.

———. *Eleven from the Reuben Gallery.* New York: Solomon R. Guggenheim Museum, 1964.

———. "Apropos of Jim Dine." *Allen Memorial Art Museum Bulletin* (Oberlin College) (fall 1965): 21–24.

Artner, Alan G. "All I Am Here For Is to Paint and Draw." *Chicago Tribune,* February 29, 1983, sec. 6, p. 19.

Ashbery, John, Pierre Restany, and Sidney Janis. *The International Exhibition of the New Realists.* New York: Sidney Janis Gallery, 1962.

———. "New Dine in Old Bottles." *New York Magazine,* May 22, 1978, pp. 107–9.

Belloli, Jay. *Jim Dine: The Summers Collection.* La Jolla, Calif.: Museum of Contemporary Art, 1974.

Boyle, R. J., and R. B. Kitaj. *Dine-Kitaj.* Cincinnati: Cincinnati Art Museum, 1963.

Calas, Nicolas. "Jim Dine, Tools, and Myth." *Metro* 7 (1962): 76–77.

Castelman, Riva. *Seven Master Printmakers:*

Innovations in the Eighties. New York: Museum of Modern Art, 1992.

Coplans, John. *Pop Art USA.* Oakland, Calif.: Oakland Art Museum, 1963.

Cotter, Holland. "Jim Dine at Pace." *Art in America* 74 (May 1986): 154.

Danoff, I. Michael. *Emergence and Progression.* Milwaukee: Milwaukee Arts Center, 1979.

De Salvo, Donna, and Paul Schimmel. *Hand-Painted Pop: American Art in Transition, 1955–62.* New York: Rizzoli International Publications; Los Angeles: Museum of Contemporary Art, 1993.

Feinberg, Jean E. "Jim Dine's Temple of Flora." *Garden Design* 4 (spring 1985): 98, 100.

Feinstein, Roni. "Jim Dine's Early Work." *Arts Magazine* 59 (March 1984): 70–71.

ffrench-Frazier, Nina. "Jim Dine." *Art International* 23 (March–April 1980): 56.

Fine, Ruth E., and Mary Lee Corlett. *Graphicstudio: Contemporary Art from the Collaborative Workshop at the University of South Florida.* Washington, D.C.: National Gallery of Art, 1991.

Gardner, Paul. "Will Success Spoil Bob and Jim, Louise and Larry?" *Artnews* 81 (November 1982): 102–9.

Gilmour, Pat. "Symbiotic Exploitation or Collaboration: Dine and Hamilton with Crommelynck." *Print Collector's Newsletter* 15 (January–February 1985): 193–98.

Goldman, Judith. "Jim Dine's Robes: The Apparel of Concealment." *Arts Magazine* 51 (March 1977): 128–29.

Gruen, John. "Jim Dine and the Life of Objects." *Artnews* 76 (September 1977): 38–42.

Haskell, Barbara. *Blam! The Explosion of Pop, Minimalism, and Performance, 1958–1964.* New York: Whitney Museum of American Art; W. W. Norton and Company, 1984.

Henry, Gerrit. "O'Hara and Dine: A Free Association." *Print Collector's Newsletter* 22 (July–August 1991): 80–83.

Hughes, Robert. "Self-Portraits in Empty Robes." *Time,* February 14, 1977, p. 65.

Johnson, Ellen H. "Jim Dine and Jasper Johns." *Art and Literature* 6 (autumn 1965): 128–40.

Kaprow, Allan. *Assemblage, Environments, and Happenings.* New York: Harry N. Abrams, 1966.

Kozloff, Max. "The Honest Elusiveness of James Dine." *Artforum* 3 (December 1964): 34–40.

Kramer, Hilton. "The Best Paintings Jim Dine Has Yet Produced." *New York Times,* January 9, 1977, sec. D.

Levin, Kim. "Digesting Dine." *Village Voice,* March 8, 1984, p. 75.

Lipke, William C. "Nancy and I at Ithaca—Jim Dine's Cornell Project." *Studio International* 174 (October 1967): 142–45.

Lippard, Lucy R. *Pop Art.* New York: Frederick A. Praeger, 1966.

Livingstone, Marco. *Pop Art: A Continuing History.* London: Thames and Hudson, 1990.

———. ed. *Pop Art: An International Perspective.* London: George Weidenfeld and Nicolson Ltd., 1991; New York: Rizzoli, 1992.

Merkel, Jayne. "Jim Dine Contemporary Art Center." *Artforum* 26 (summer 1988): 144.

Paparoni, Demetrio. "The Memory of Death: Jim Dine." *Tema Celeste* 17–18 (October–December 1988): 28–33.

Prints by Five New New York Painters: Jim Dine, Roy Lichtenstein, Robert Rauschenberg, Larry Rivers, James Rosenquist. New York: Metropolitan Museum of Art, 1969.

Ratcliff, Carter. "Jim Dine at Pace." *Art in America* 65 (May–June 1977): 116.

Ruzicka, Joseph. "Jim Dine and Performance." In *American Art of the 1960s,* pp. 96–121. New York: Museum of Modern Art, 1991.

Schjeldahl, Peter. "Artists in Love with Their Art." *New York Times,* November 3, 1974, sec. D, p. 30.

Seitz, William. *The Art of Assemblage.* Garden City, N.Y.: Doubleday and Co., 1961.

Shapiro, David. "Jim Dine's Life in Progress." *Artnews* 69 (March 1970): 42–46.

Solomon, Alan R. "Jim Dine and the Psychology of the New Art." *Art International* 8 (October 1964): 52–56.

———. Introduction to the United States section in *Catalogo della XXXII Esposizione.* Venice: Biennale Internazionale d'Arte, 1964.

———. *American Pop Art.* Amsterdam: Stedelijk Museum, 1964.

———. *The Popular Image Exhibition.* Washington, D.C.: Washington Gallery of Modern Art, 1963.

Sparks, Esther. *Universal Limited Art Editions: A History and Catalogue: The First Twenty-five Years.* New York: Harry N. Abrams; Chicago: Art Institute of Chicago, 1989.

Stevens, Mark. "Color Them Masters." *Newsweek,* February 14, 1977, p. 81.

Tallmer, Jerry. "Jim Dine: When the Image Changes. . . ." *New York Post Magazine,* January 22, 1977, p. 10.

Tomkins, Calvin. "Profiles." *New Yorker,* June 7, 1976, pp. 42–76.

Zeleransky, Lynn. "Jim Dine's Early Work, Sonnabend." *Artnews* 83 (May 1984): 159–61.

Films

Jim Dine. 1965. Directed by Lane Slate and produced by National Educational Television. 16mm.

Jim Dine, London. 1971. Produced by Blackwood Productions. 28 minutes, color, 16mm.

Jim Dine: Childhood Stories. 1992. Directed by Peggy Stern for Outside in July, Inc. 30 minutes, color, 16mm.

Index

Photography Credits